5-MINUTE SKETCHING
ANIMALS & PETS

A FIREFLY BOOK

Published by Firefly Books Ltd. 2017

First printing

Publisher Cataloging-in-Publication Data (U.S.)

Library of Congress Cataloging-in-Publication Data is available

Library and Archives Canada Cataloguing in Publication

Geraths, Gary, author
 Animals & pets : super-quick techniques for amazing drawings / Gary Geraths.
(5-minute sketching)
Includes index.
ISBN 978-1-77085-917-3 (softcover)
 1. Animals in art. 2. Domestic animals in art. 3. Drawing--Technique.
I. Title. II. Title: Animals and pets. III. Series: 5-minute sketching
NC780.G47 2017 743.6 C2017-902164-8

Published in the United States by
Firefly Books (U.S.) Inc.
P.O. Box 1338, Ellicott Station
Buffalo, New York 14205

Published in Canada by
Firefly Books Ltd.
50 Staples Avenue, Unit 1
Richmond Hill, Ontario L4B 0A7

Printed in China

Conceived, designed, and produced
by RotoVision
4th Floor Ovest House
58 West Street
Brighton,BN1 2RA
England

Publisher: Mark Searle
Editorial Director: Isheeta Mustafi
Commissioning Editor: Alison Morris
Editor: Nick Jones
Junior Editor: Abbie Sharman
Cover Design: Michelle Rowlandson
Page Design: JC Lanaway

Image credits

Front cover (from top to bottom, left to right):
Shelby Peterson, Gary Geraths, Gary Geraths, Virginia
Hein, Gary Geraths
Back cover (from top to bottom):
Gary Geraths
Opposite: Gary Geraths

5-MINUTE SKETCHING
ANIMALS&PETS

Super-quick Techniques for Amazing Drawings

GARY GERATHS

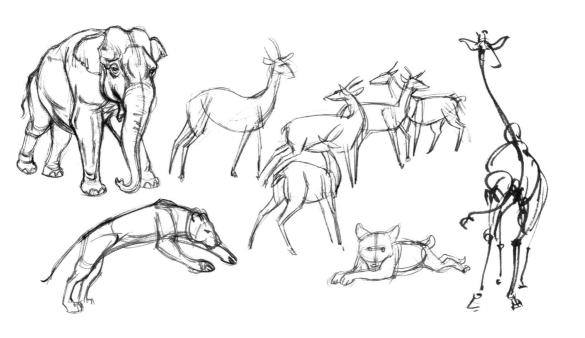

FIREFLY BOOKS

Contents

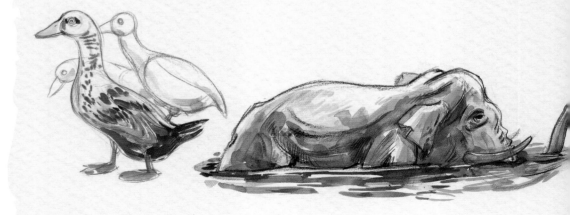

Chapter 3

FLESHING OUT YOUR SKETCH 66

Chapter 4

MATERIALS AND TECHNIQUES 92

Introduction

AS ARTISTS, we are continually being challenged and confronted by new subject matter, materials and methodologies. We accept this, reasoning that it makes our creative process more varied and fulfilling. In drawing and painting, I find that animals are among the most compelling subjects I can engage with. Nothing makes me more excited than throwing my sketching materials into a pack and going out for a day at the zoo or a local dog park to furiously scribble in a notebook. I've been in this drawing business for over 40 years and am still amazed at how exhilarating and yet frustrating it can be to produce a series of dynamic, solid, five-minute animal sketches. In this book, we will be taking that journey together, discovering there is nothing more satisfying than first struggling with, and then nailing down, a grouping of drawings that capture the implied movement, character and personalities of animals.

It's always an exciting struggle between choosing an analytical or intuitive approach as you quickly sketch animals. In the following chapters, you will learn how to juggle and balance a wide variety of simple techniques and essential materials to accomplish your mission. Chapter 1 deals with the fundamentals of where to find animals and how to use various drawing materials and new methods to create substantial and vigorous sketches. Chapter 2 builds on this foundation by concentrating on how to fill in the volumetric structure, form and texture, allowing the personalities of the creatures to emerge, with topics on heads, portraits, markings and fur. Chapter 3 pushes into powerful directions with muscle anatomy and animated design and value, aiming for an energetic and complete appearance in your drawings. Lastly, Chapter 4 ties the process together by showing how to use a wide array of artistic materials to give your newly learned techniques a vision and successful resolution.

This whole process of design, composition and dynamic sketching will require your committed involvement and lots of practice, and will most certainly entail a lot of mistakes! There will be a great amount of self-

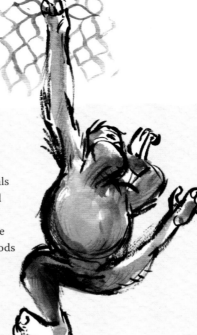

reflection, critical thinking and, no doubt, bad sketching involved in learning how to draw animals in five minutes. But bear in mind that the ups and downs of the artistic performance are part of the excitement. Frequently, you will have to be outside your comfort zone, but learning all of these methods will give you a big edge in producing successful artworks on any subject, not just animals.

Ultimately, it's all about how you use all of these varied techniques and build the confidence to give your drawings a liveliness and solidity. I've had some great experiences drawing wild and domestic animals all over the world, whether it be quickly sketching yaks in the alpine regions of Tibet, beautiful birds in tropical rainforests, bison and deer in the American West, herds of sheep in Britain, or hundreds of different animals, birds and reptiles in zoos, parks and equestrian centers. But it's worth noting that some of my best sketches have been of the family dogs sitting on the rug in my front room.

In this book I have compiled all of the techniques, methods and tips that have helped me grasp and simplify the process of drawing animals in five minutes. Now it's up to you to start sketching, painting, erasing, grabbing a new drawing material, messing that up, and then trying and succeeding in your practice. Study your subjects, gather up your pencils and paints and get out sketching as soon as possible to enjoy the whole amazing experience.

Gary Geraths

Above **Virginia Hein,** *Swinging Orangutan,* **2014.**
With a confident brush, Virginia vigorously drew this playful orangutan hanging from zoo netting. The drawing was begun with black ink before watercolor was painted into the contours.

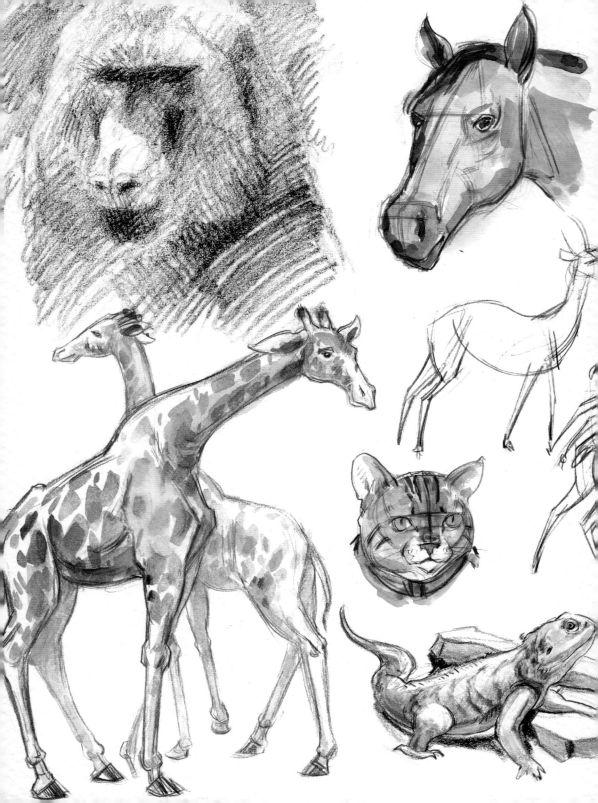

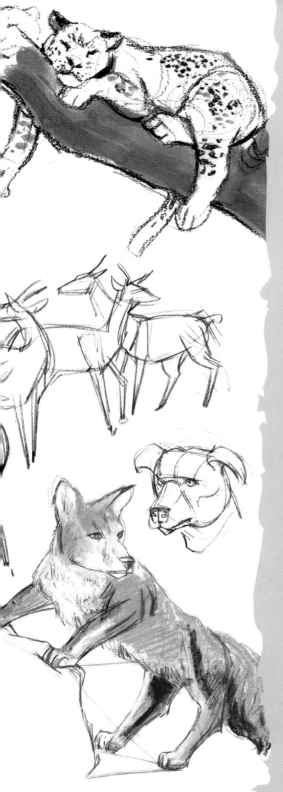

Materials and basic methods

These will be the first steps on your journey to understand, experiment, sketch and attain the ability to confidently draw animals in five minutes. In this chapter are the building blocks to start you out, with useful information on sketching locations, animal construction, techniques and drawing materials. Fundamental to learning and practicing your craft is keeping the process as simple and uncomplicated as possible. Ask yourself what the objective is you're aiming for. Which media will best express the animal's movement or personality? Many questions will arise in the process but you will learn to answer them; to mold the building blocks of drawing to realize your vision and create images of a wide range of creatures. Take this knowledge and these techniques, put them on paper and make great animal drawings and paintings.

Left There are no boundaries when it comes to the materials artists can use to create animal art. The animals on this page were drawn in ink, pencil, pastel, marker and watercolor.

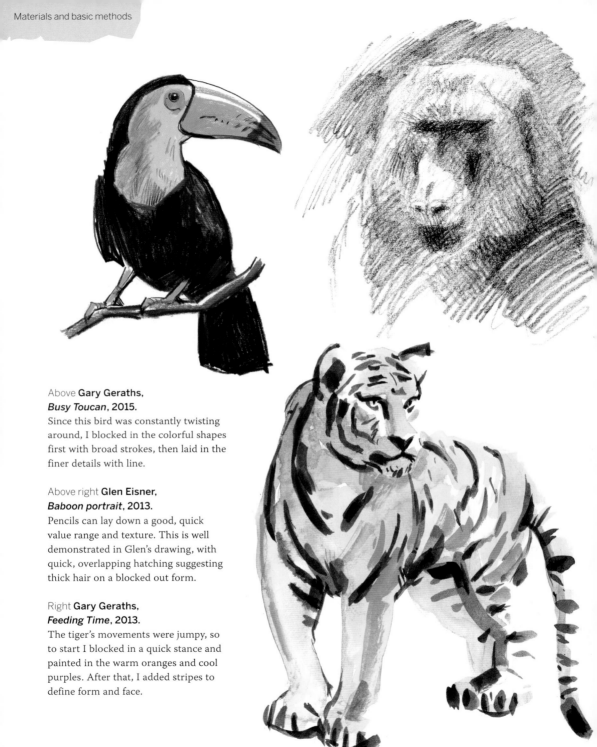

Above **Gary Geraths,**
Busy Toucan, 2015.
Since this bird was constantly twisting
around, I blocked in the colorful shapes
first with broad strokes, then laid in the
finer details with line.

Above right **Glen Eisner,**
Baboon portrait, 2013.
Pencils can lay down a good, quick
value range and texture. This is well
demonstrated in Glen's drawing, with
quick, overlapping hatching suggesting
thick hair on a blocked out form.

Right **Gary Geraths,**
Feeding Time, 2013.
The tiger's movements were jumpy, so
to start I blocked in a quick stance and
painted in the warm oranges and cool
purples. After that, I added stripes to
define form and face.

Basic drawing materials

You're ready to start drawing animals, but which materials do you use? Frequently drawing animals will mean going out in the field where being mobile in both thought and equipment is the key. Here are some tips on which drawing media will best suit your needs and allow you the best artistic expression.

Tips to get you started

1 **Pencils and colored pencils** Graphite and colored pencils are easy to buy and maintain, and give you a wide range of line and tone. Graphite pencils range from 6H (hard) to 6B (soft). See how they can be combined to express delicate line and broad values on paper. Colored pencils may be harder to erase but have a waxier flow over the page and capture fluid movement well without potentially smearing like graphite.

2 **Ink pen and brush** A good tool set to try is waterproof ink, fountain and ballpoint pen. These fluid media can give you more gestural images. Also useful is a brush pen — a self-contained, refillable or cartridge paintbrush that creates a calligraphic set of lines and tones. These broad painting strokes can be combined with playful lines of fountain or ballpoint pen to give your drawing a successful layering of lighting, texture and movement.

3 **Water media** Watercolor and gouache are both wonderful, expressive colorful media. You can buy or make a handheld kit, which can be used with portable water cartridge brush pens. Lay down a quick pencil sketch as a simple framework, then block out the animal's covering in broad, colorful strokes.

4 **Markers, pastels and charcoal** These materials can make for some very exciting results. With markers, you can really get a consistent, solid group of values and marks. They are great at overlapping fields of tones, dry quickly and can be used with various other mixed media. Pastel and charcoal can lead to some very creative outcomes, but special care must be taken not to smear and damage your drawings. The grittiness of the materials can add a great weight and depth to your field sketches, but without care can also give smeared-in "ghost" images.

5 **Sketchbooks** If you need to buy a sketchbook, decide what fits your needs in the field and do a little research before you purchase. There are two basic models. I prefer the spiral ring book over the hard bound, because when you fold it over, it becomes more compact and easier to handle. Look at the paper quality. Consider the fact that thinner paper may not be able to take watercolor and ink. In fact, the condition of the paper may be more important than the drawing tools, because that's the surface on which you will sketch your artistic vision.

Places to practice

Now that you have your gear, it's time to go and find subjects to draw. When you discover all the great places to visit, you'll unlock a vast array of animals to examine and sketch. Different locations deliver different subjects, allowing you to fill a sketchbook with a diverse assortment of creatures.

Tips to get you started

1 **The zoo** Zoos are prime locations to seek out exotic animals, large and small. A good strategy is to acquaint yourself with the zoo map and see what it has to offer to draw, and where certain kinds of animals (African, Asian, etc.) are grouped. Then take a quick walk through to see the best viewing angles and areas of the animal enclosures. Animals will frequent certain places within their enclosures; knowing where to stand and draw them leads to less frustration in seeking them out.

2 **Natural history museums** Surprisingly a museum is a good place to visit, observe and sketch at. As you sketch live animals at various venues, it can become frustrating trying to draw the finer details of heads and the anatomy of animals on the move. Museum dioramas offer a great opportunity to sit down and focus on figuring out animal anatomy. It is a great place when you want to sketch on a rainy day, and a way to gather insight for use in the field.

3 **Equestrian centers and stables** Equestrian centers will frequently have horses and riders working out, and jumping events that you can sketch. One positive is that the horses run through a set course of obstacles to jump,

allowing you to watch them repeatedly and draw the action successfully. For portraits, go over to the stables and sketch the horses as they poke their inquisitive heads out to take a look at what you are doing. Don't get too close; I've had a couple of overly friendly horses nibble at my drawings!

4 **Dog parks and pets at home** Nothing beats going out and finding a bench at a public dog park and sketching playful animals. Of all the animals you will draw, dogs have the greatest varieties of size, shapes and movement. Their actions are good to draw with a fast, searching line. If you are drawing pets at home, you have ready subjects. Most likely your pets are comfortable around you, so on stormy days or at night, you have a willing model to draw.

5 **Farm animals** Often when I am driving out in the country, I will pull over my car if I spot a herd of cows, sheep or goats munching grass in the field. They may not be close enough to draw details, but distant subjects are always good to define shape and proportion.

Above **Gary Geraths, *Oats for Roma*, 2016.**
At stables, your models are literally framed in a doorway and inquisitive about what you are doing. Horses love attention, so get up and personal and draw some portraits.

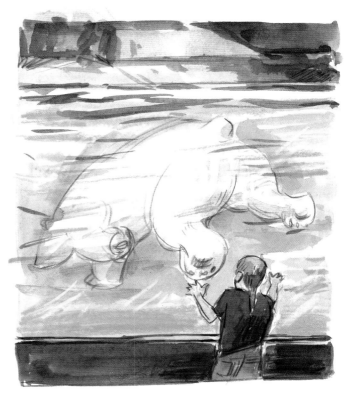

Above **Gary Geraths, *"Never Seen That!"*, 2015.**
A watercolor and pencil sketch of an amazed child watching a swimming polar bear. Sometimes it's more about storytelling rather than just drawing the animal.

Left **Virginia Hein, *Playful Seals*, 2009.**
Aquariums offer the experience of watching through glass as creatures frolic in water tanks. Virginia drew joyful seals with different forms and comical faces, showing a variety of actions.

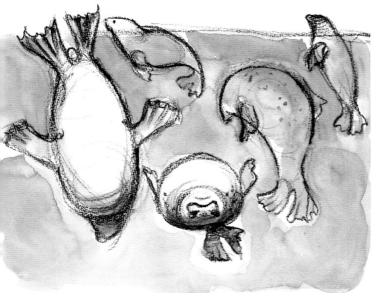

Below **Gary Geraths,**
Silverback Gorilla, **2014.**
I painted this big male gorilla's posture to stress the animal's shape, bulk and strength. All of the limbs are highlighted to show the pose and power.

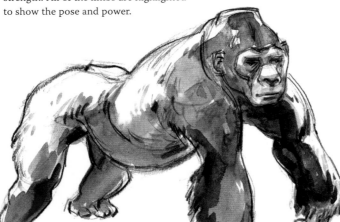

Above **Gary Geraths,**
Resting Kangaroo, **2008.**
Many animals have extremes in large and small body shapes. Use the negative shapes that surround the figure to get the pieces working in concert and to get the proportions right.

Below **J.A.W. Cooper,**
Fluffy Puppy, **2016.**
Jessica took a simple, fluid approach by using the side of the pencil to draw in a simple silhouette that tells the story of the dog's shape and soft textures.

Right **Gary Geraths,**
Giraffe Couple, **2015.**
When you are drawing several creatures simultaneously, try to spread the details throughout the animals to tie the group together visually. Here I made sure the foreground giraffe was clearly drawn.

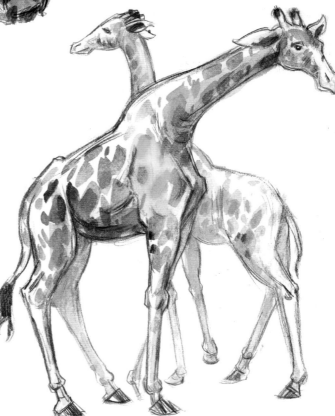

Looking and seeing

So, you have pencil and paper in hand; how do you begin your journey of animal sketching? It's worth noting that you will be making a lot of mistakes as you work toward producing successful sketches. With that in mind, here are a few pre-visualization tips. Remember that it's partly a mental process, coupled with fast and furious drawing to produce satisfying results.

Tips to get you started

1 **Safety in numbers** Rather than choosing subjects that move quickly (dogs) or elusive creatures (big cats), seek out an enclosure with several of the same animals inside, like giraffes or large, slow-moving creatures such as cattle or elephants. Often subjects will repeat each other's positions and movement when they are in a group. Then you can put together a single image from the different pieces of many different subjects. Believe me, no one will know the difference. It's our secret!

2 **Slow-moving simplicity** Step back and choose to observe larger, slower creatures, such as giraffes or cows. Observing animals of a greater size allows you to compare the size and shape of the larger masses with the small sections of the legs and head. The qualities of movement and rhythm are easier to grasp as you sketch and edit.

3 **Easy silhouettes** It's easy to lose your visual organization of the animal in multiple confusing parts and troublesome foreshortening. Find a profile view to start with and get rid of all those pesky details. Construct the animal as simple shapes and proportions. Remove any visual clutter and make sure you understand it as graphically clear. Where is the subject widest? Thinnest? What shape is the head, the angle of the back and so on? This method takes a lot of the worry out of the process.

4 **Substance before style** Let your style drop into the background. As you step back and combine thinking and drawing together, there is a creative tide, an ebb and flow between your method and the structural matters in a dynamic drawing. Wrap your brain around the simple constructive framework and the animal's movements. When you can mentally shift gears between all of these approaches, your style will become more informed.

5 **Assigning visual qualities** As you begin sketching and combining various concepts and methods, assign names and descriptions to your subject(s). This can help shape and guide your image smoothly and simply. These impressional qualities — such as strength, power, subtleness, speed, slimness, balance, grace and even beauty and ugliness — can accentuate your fast sketches.

Implied movement

One of the most satisfying things about sketching animals is capturing
the essence of gesture and movement. All animals have various character of
action, ranging from blazingly fast to slow as molasses. Using these ideas and
techniques can flavor and guide your drawing, leading to more dynamic images.

Tips to get you started

1 **Grab the action** Remember that most of
an animal's energy comes from the back legs
and is transferred to the front of the body/
legs via the spine. Sketch the line of action
through the spine. These first fluid lines
combine the expressive qualities of movement
from the tip of the nose to the tail. Over that,
you can lay in the basic structural forms. These
shorthand abbreviations will give your work a
fresh, dynamic look.

2 **Lines of rhythm** After laying down the
armature of supporting lines, you can start to
break them up into shorter curving lines for the
legs, the neck and so on. Drawing those lines
will give you a stand-in for the recognizable
form, as well as an overall sense of order and
clarity. A big plus is that everything in your
sketch will be organic and changeable. This
allows you to harmonize and prioritize
your decisions while building your image.

3 **Strong impressions** By now you will be moving
confidently and applying repetitive lines, so
your eye will be moving around and through the
subject. You are building on the essence of the

action with ripples of lines, describing the
action like the ripple and flow of coursing water.
These lines and tones should come in lengths
short and long, thick and thin.

4 **Straight and curving marks** A great method
to add to your gesture drawing is comparing
and contrasting curved and angular lines. The
idea behind this technique is that the curving
line focuses on organic, stretching forms, while
dynamic structural support is conveyed by a
framework of straight marks. It helps toward
building an exciting composition.

5 **Cohesive expression** No matter how much
crazy action you are drawing, the image has
to be cohesive. Your sketch should be filling
up with various pieces of action and graphic
anatomical information. This is important, no
matter the creature you are sketching. Airborne
birds must communicate flight; swimming seals
a sleekness in water; reptiles convey slithering
over the ground and around tree branches.
Gesture is movement and life.

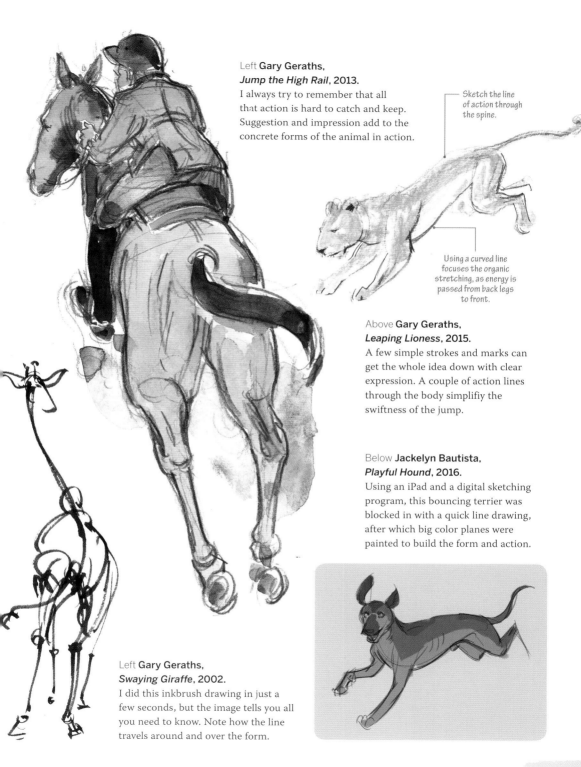

Left Gary Geraths,
Jump the High Rail, 2013.
I always try to remember that all
that action is hard to catch and keep.
Suggestion and impression add to the
concrete forms of the animal in action.

Sketch the line
of action through
the spine.

Using a curved line
focuses the organic
stretching, as energy is
passed from back legs
to front.

Above Gary Geraths,
Leaping Lioness, 2015.
A few simple strokes and marks can
get the whole idea down with clear
expression. A couple of action lines
through the body simplifiy the
swiftness of the jump.

Below Jackelyn Bautista,
Playful Hound, 2016.
Using an iPad and a digital sketching
program, this bouncing terrier was
blocked in with a quick line drawing,
after which big color planes were
painted to build the form and action.

Left Gary Geraths,
Swaying Giraffe, 2002.
I did this inkbrush drawing in just a
few seconds, but the image tells you all
you need to know. Note how the line
travels around and over the form.

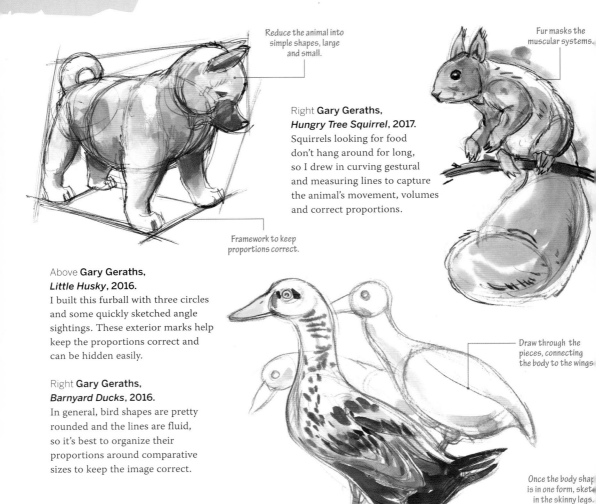

Reduce the animal into simple shapes, large and small.

Fur masks the muscular systems.

Right **Gary Geraths,**
Hungry Tree Squirrel, 2017.
Squirrels looking for food
don't hang around for long,
so I drew in curving gestural
and measuring lines to capture
the animal's movement, volumes
and correct proportions.

Framework to keep
proportions correct.

Above **Gary Geraths,**
Little Husky, 2016.
I built this furball with three circles
and some quickly sketched angle
sightings. These exterior marks help
keep the proportions correct and
can be hidden easily.

Right **Gary Geraths,**
Barnyard Ducks, 2016.
In general, bird shapes are pretty
rounded and the lines are fluid,
so it's best to organize their
proportions around comparative
sizes to keep the image correct.

Draw through the
pieces, connecting
the body to the wings

Once the body shape
is in one form, sketch
in the skinny legs.

An otter may be
three times longer
than its height.

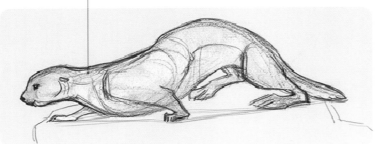

Left **Abi Savage,**
Otter Diving, 2016.
Abi drew this sea otter as a long
curving tube to anchor the action,
but still managed to use the height
and length measurements to get
the proportions right.

Basic proportions
— little animals

Nothing is more enjoyable than getting up close and personal,
watching and drawing little animals with boundless amounts of energy.
With all that movement and their compact bodies, it's important you tune
into the character and proportions to get the image right.

Tips to get you started

1 **Little framework** Because smaller animals tend to have a lighter skeleton and more body volume, that frequently means curved edges and circular forms. Don't miss adding swirling lines and overlapping convex and concave lines. Once again, this is about reducing the creatures into simple shapes, large and small, and comparing sizes.

2 **Fur and form** Sketching small animals means you have a lot more variety of subjects, whether it be rabbits, birds, squirrels, hens, ducks, cats, dogs — even hamsters! A good approach to comparing and contrasting the differences is to look at the head and body size. Frequently, smaller animals haven't developed muscular systems that show on the surface, not least because they are covered in fur.

3 **Forms and feet** When you are sketching quickly, it's important to relate all of the body parts to the whole image you draw, because small animals haven't developed defined necks. Many small animals' heads appear to attach directly to their bodies. There is a streamlined

but rounded appearance. Out of those forms emerge legs and feet, with their own character and proportion.

4 **Quick comparisons** With all of this quick sketching of a quick animal, it's important to compare the height, length and width of the small creature. Then you can easily turn the proportions into a ratio. A rabbit may be the same measurement, one-to-one, whereas a dachshund or ferret may be three times longer than it is high. This also works in comparing width to length.

5 **Birds in flight** When it comes to drawing birds on the ground and in flight, be aware of the interplay between the body and the wings. Many birds have a pear-shaped body with a short neck, triangular head and wings of various shapes and sizes. A great strategy is to draw through all those pieces, connecting the body and wings together in one form, and then sketch in those skinny little legs with talons. These quick shape sketches can have a sense of movement and liveliness.

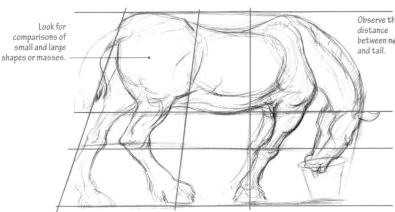

Look for comparisons of small and large shapes or masses.

Observe th distance between n and tail.

Note where the angles show on the animal's form.

Compare height to width.

Right **Gary Geraths,**
Big Old Draft Horse, **2012.**
As I drew this Clydesdale I furiously blocked in the body and the measuring with vertical and horizontal axis lines to keep the sketch organized.

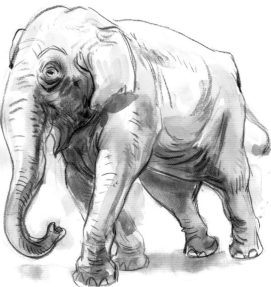

Left **Gary Geraths,**
On the Move, **2011.**
Drawing elephants means using big forms, so best to sketch lightly and watch how all the conflicting volumes overlap one another, then organize them in order.

Below **Nikolai Drjuchin,**
Grizzly Miss Montana, **2015.**
Big animals can be simplified down to shape design. The key to getting it right is to compare the smaller forms with the big ones and compare the proportions.

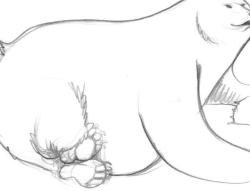

Left **Gary Geraths,**
Long Neck Feeding, **2010.**
Large animals like this stretching giraffe have unusual shapes and dimensions. Pay special attention to the height and width measurement as you quickly sketch.

Basic proportions — big animals

Now we move on to drawing large animals, using proportion to achieve believable artwork. When five-minute sketching, you will be observing and drawing at a quickened pace, and so proportions can easily get out of hand. Using these tips will make the act of drawing a more satisfying experience.

Tips to get you started

1 **Points in space** When quickly sketching a larger animal, your eyes must scan larger distances between body forms to get all of the animal's figure pieces to work as a whole. Note where the skeletal framework and angles show on the animal's surface form. This will give you reference points to compare your various measurements. Think of it as connecting the dots to gauge shape and size.

2 **Figure in the round** To help judge the proportions of your subject, find the larger forms and measurements. Observe the distance between the tip of the nose and the tail, then compare that to the distance between the top of the head and the toes. Take it one step further and contrast those measurements with the widest section of your subject. This gives you a sculptural vision of the animal.

3 **Silhouettes not outline** One of the most important points — and occasional pitfalls — of quick sketching large animals is the tendency to apply a heavy outline around your animal drawing. Although this may give a solid look and appearance, it's hard to change the proportions if they are out of scale. Better to sketch over and around the subject's form, looking for comparisons of small and large shapes and masses. Yes, silhouettes are important to gauge the simplicity of your subject, but so is drawing with a sense of form.

4 **Changing shapes** When you are moving from one animal to another, the sizes may change, for example from vertical giraffes to horizontal Komodo dragons to big, blocky elephants. If you apply the proportions in a practical, organic manner, you can see the differences and similarities across several animal groupings.

5 **Moving targets** All this gauging of proportion and measuring doesn't have to be wooden and stiff. The aim is to achieve a fluid method combining structure, proportion, movement and imagination into one artistic package. Using measurements gives a sense of reason and believability to your creations. It's one aspect of harmonizing and giving a sense of order to your work in the field.

Below Gary Geraths,
Cat's Head, 2017.
I laid out this sketch with a focus on combining those horizontal axis lines along with that big round kitty head. The circular ears, eyes and cheeks connect the portrait features together.

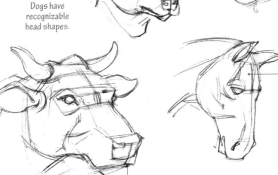

Dogs have recognizable head shapes.

All cats have ovoid head structures.

Cattle have square, box-like heads.

Horses have rectangular-shaped heads.

Above Gary Geraths,
Basic Head Types, 2017.
I simplified these various heads down to their most basic proportional structures and shapes. I practice drawing these religiously so I know them before I sketch them in situ.

Primates have human-like heads.

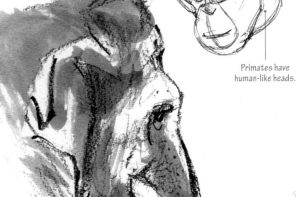

Above Virginia Hein,
Billy's Profile, 2009.
With a sure hand, Virginia made this charcoal and ink drawing to capture a combination of anatomy and character. Note how the wet ink flow pulls the creature's head proportions together.

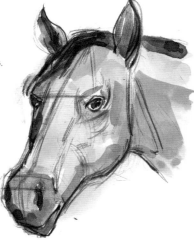

Above Gary Geraths, *Stable Horse*, 2017.
In drawing a horse's head I combined basic shape, a strong jaw, axis lines and tapered muzzle to keep the elements in order. Organization is the key to success.

Basic proportion — heads

It's vital to pay attention to creatures' heads and faces. Though drawing body markings, textures and implied movement will give your artwork character and believability, getting the head and portrait right — even just hinting at them — will give your work personality and make the animal recognizable.

Tips to get you started

1 **Head shapes** Since the head is such a key part of making your sketch lifelike, it's important to get a handle on the shapes and proportions. At this point, details and features are your enemy; unless they are placed in the right place, at the right size, your image will fall apart. To start, build around basic structural forms. Cattle have square, box-like heads; horses, giraffes and antelopes have rectangular ones; the heads of cats (big and small) are ovoid. Every animal has a simple head form.

2 **Feature design** Now proportion and correct placement of the features come into play. After getting the basic head shape and form, use length and width axis lines. These simple marks act as place markers for the features. Remember, you will be working furiously, so abbreviation and simplicity are the key. Move back and forth over the form to establish the connection between the muzzle, mouth and eyes, forming a cohesive, shorthand portrait.

3 **Where are the eyes?** Think of how the animal is built for living in the natural world. Cattle-like herbivores have eyes facing out on both sides of the head to watch for predators. Horses' eyes are placed closer to the front. Dogs' eyes are designed for pack hunting and so are positioned toward the front of the skull. Cats' eyes are focused exclusively forward in order to hunt for prey. Correctly position those eyes and muzzles, and you are halfway there!

4 **Noses and nostrils** Sculpt your drawing by adding soft tissue around the mouth and nose. Apply the knowledge that cats have triangular noses; birds' beaks can be simplified to pointy cones; cattle, rhinos and camels have square muzzles. Many animal nostrils can simply be sketched as "commas," and ears as tear-shaped cups.

5 **Apes and heads** With ape and primate heads, we can use a different set of forms and rules. It is easy to visualize the human head structure as a basic form, and here the proportion and structure are very similar. Generally the eyes are located in the center of the head, with the nose and mouth arranged in a human-like pattern. To keep the features organized, look for a "figure eight" surrounding the features — wide at the eyes and mouth, pinched at the nose. With just enough time left to complete the sketch, focus on the personality in the eyes for a bit of soul.

Focus on shapes

Frequently, when your subject is moving from one place to another, the shape and dimensions of the animal become a great, simple idea to rely on. Being able to tune out the visual noise of features, details and textures to create a solid, recognizable image can have a calming effect in your sketching.

Tips to get you started

1 **Shape design** When your drawing starts to go off track, a great organizing method is to use simple shape design. Think of it is as if you are taking the measure of your subject and cutting out the flat shape perimeter of the animal. Then, the next step is to look for the hierarchy of forms by blocking out the head shape and legs and "gluing" them to your simple body shape. This creates order between the primary body form and moving parts.

2 **Small shapes** After getting a handle on the primary form shapes and proportions, you can break it down into smaller shapes. These new shapes can be layered over the first ones to represent the forms of the legs attached to the torso, the ears, nose and even unique features like horns, antlers and elephant trunks! Stick to simple, manageable shapes to organize before you start to mold them into organic forms. Triangles for wings, beaks, ears and horns; long, curving rectangles for various animal tails.

3 **Shape sculpting** Now you have that primary statement, make it more varied by carving into the edges with the areas of soft tissue and rounded lines. These comparisons make for a more dynamic image with an interplay of structure and movement in line and tone. The big, simple shape gives it visual strength and recognizable solidity; the smaller complex shapes give it life and a fuller appearance.

4 **Shape welding** Heads are often intimidating, which leads to frustration and an unwillingness to tackle a subject. Any subject can be broken down into a series of shapes. Take, for instance, a horse's head. Use a rounded form for the jaw and upper skull, a squarish shape for the muzzle, and glue on a kite shape that spans the top of the head to connect the pieces. Then to complete the portrait, triangles, circles and ovals can be used for the ears, eyes and nose.

5 **Birds and wings** Drawing birds uses the same shapes but needs a different set of rules to organize the image. If the bird is resting with its wings folded onto its body, the shapes are simple and rounded with a bit of angularity at the head and a triangular beak and tail. Once in flight, the wings and tail expand and the proportions and addition of shapes expand greatly. Keep a flexibility in the process, but make the shapes solid enough to keep that bird in the sky.

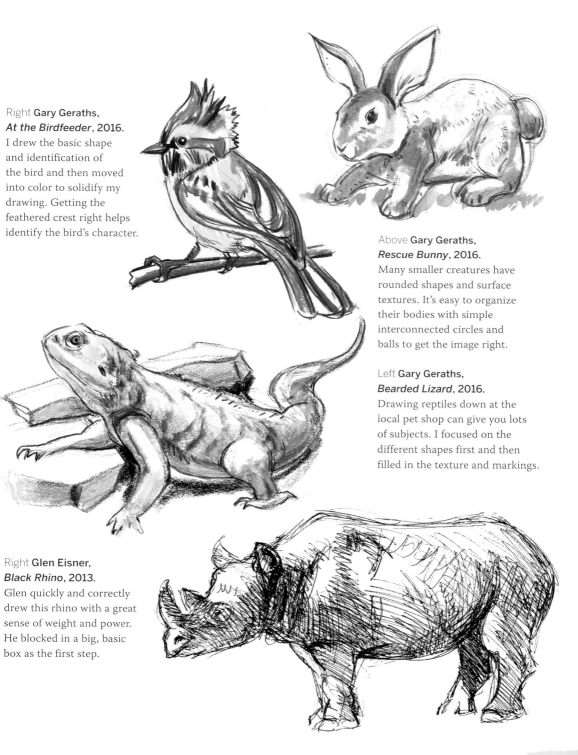

Right **Gary Geraths,**
At the Birdfeeder, 2016.
I drew the basic shape
and identification of
the bird and then moved
into color to solidify my
drawing. Getting the
feathered crest right helps
identify the bird's character.

Above **Gary Geraths,**
Rescue Bunny, 2016.
Many smaller creatures have
rounded shapes and surface
textures. It's easy to organize
their bodies with simple
interconnected circles and
balls to get the image right.

Left **Gary Geraths,**
Bearded Lizard, 2016.
Drawing reptiles down at the
local pet shop can give you lots
of subjects. I focused on the
different shapes first and then
filled in the texture and markings.

Right **Glen Eisner,**
Black Rhino, 2013.
Glen quickly and correctly
drew this rhino with a great
sense of weight and power.
He blocked in a big, basic
box as the first step.

25

Moving overlapping volumes

When sketching, nothing gives you more confidence than being able to shift gears between using flat, graphic shapes, and using measurement within dynamic forms in three-dimensional space. This will allow you, as an artist, to draw with knowledge and without hesitation.

Tips to get you started

1 **Twist and turn** Take the flat shapes described in earlier topics and add forms that allow you to twist, turn and apply them to your gestural sketch. Squares will become cubes; rectangles become boxes; circles into spheres, and triangles change to cones and pyramids.

2 **Forms in space** When applying these large volumes to your sketch, keep them simple, recognizable and within the proportions you designed in your first lines and marks. Since most of the time you will be drawing the animals in action, you will have to show your subject in foreshortened poses that display a lot of dynamic overlapping forms. Boxes can be substituted for heads, tubes for necks and long legs, and squared-off cylinders and wedges for torsos and leg muscle groupings.

3 **Form collisions** Overlapping volumes in your drawing give you depth and sculptural form. After understanding how these large, simple forms can be stand-ins for more complex animal bodies, you can move on to applying smaller volumes that accent your vision.

These small forms are especially useful in building the character of the head and "feet" of your subject. Legs and hooves can take on the simple forms of tubes and wedges. For heads, smaller forms can build cheeks, ears and noses.

4 **Dynamic marks** When you put all of these forms into a cohesive package in perspective, the volumes of different sizes collide, making for overlapping forms that produce a pattern of overlapping lines and values. Accent where the volumes come together. You will notice more details in the foreground and light lines and details edited out in the background.

5 **Flowing core shadows** All forms in nature have light and shadow patterns flowing over them. These various forms, even when changed, distorted or masked together, show a break between major light and dark planes. At that meeting place between these major planes, there is a "core shadow," or "pathway," that runs the length of all forms, large and small. As you move into using media that expresses shading, you will be sketching with imagination.

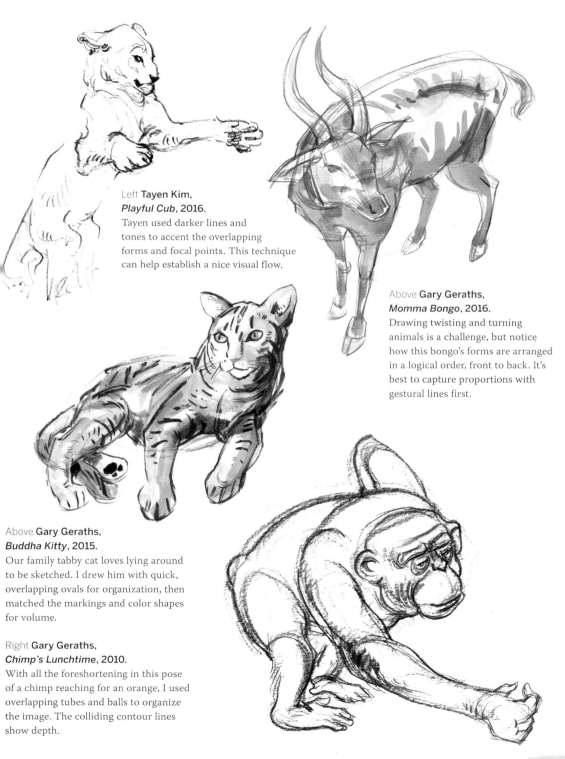

Left **Tayen Kim,**
Playful Cub, 2016.
Tayen used darker lines and
tones to accent the overlapping
forms and focal points. This technique
can help establish a nice visual flow.

Above **Gary Geraths,**
Momma Bongo, 2016.
Drawing twisting and turning
animals is a challenge, but notice
how this bongo's forms are arranged
in a logical order, front to back. It's
best to capture proportions with
gestural lines first.

Above **Gary Geraths,**
Buddha Kitty, 2015.
Our family tabby cat loves lying around
to be sketched. I drew him with quick,
overlapping ovals for organization, then
matched the markings and color shapes
for volume.

Right **Gary Geraths,**
Chimp's Lunchtime, 2010.
With all the foreshortening in this pose
of a chimp reaching for an orange, I used
overlapping tubes and balls to organize
the image. The colliding contour lines
show depth.

Right **Kayla Ryyth,**
Sleeping Fox, 2014.
When sketching a reclining or resting
animal — especially using forced
perspective, as in Kayla's drawing —
it's a good idea to place them on a
solid ground plane.

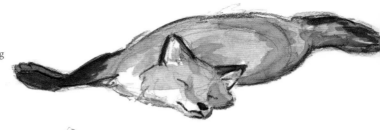

Left **Gary Geraths,**
Fox on the Move, 2017.
When an animal starts climbing up
terrain or objects, it's important that
all the forms and limbs work together.
Placing them on a perspective grid
keeps the pieces working in concert.

Triangle lines
help organize
legs.

Lines keep hooves
in order.

Above **Gary Geraths,**
Preening Giraffe, 2013.
Perspective does not have
to be a ponderous and
complicated thing. A simple
triangle keeps the legs and
hooves together.

Right **Gary Geraths,**
Twisting Giraffe, 2013.
In this sketch of the back of
a giraffe's neck and head, it
was crucial that all the forms
connected together. I used
the angles and perspective
in concert to get it right.

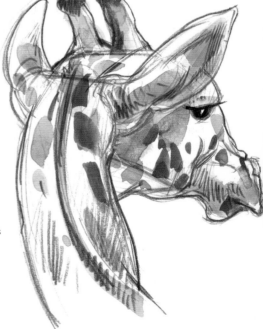

Perspective in action

Part of the illusion you are striving to create is that the subject animal is standing, sitting, climbing, laying down or jumping onto the ground. If you think about it, even birds are "attached" to the sky. Even if you don't sketch in the terrain, you should at least acknowledge it for a dynamic drawing.

Tips to get you started

1 **Elastic perspective** When we talk about using perspective, it's in a fluid sense. Generally speaking you won't be drawing solid buildings with a ridged "footprint" on a flat plane, but more likely creatures that are situated on uneven surfaces and objects; either way, the animal has to be connected to the ground in a convincing way. Use the first lines coming off the gesture as simplified "legs" to address that.

2 **Standing on all four feet** Consider the angle from which you are viewing the animal. Is it a frontal view? If so, chances are the animal will present a taller and narrower image that needs the stable attachment of feet to the ground. A profile view means that all four legs will show and the front and back feet will have to work together to support the animal's proportion. Attaching the feet to the ground allows us to see the height, width and length measurement.

3 **Measurements in motion** When your subject is on uneven ground, such as walking up a slope or down a gully, stretching up to eat leaves from a tree, or climbing rocky steps, the perspective changes drastically. A good method that will help you handle this is to envision and draw boxes, ovoid and cone volumes in various

perspectives. I suggest starting out as simply as possible and just building your image in a box that conforms to the animal in perspective.

4 **Organizing axis lines** To help organize an animal's movements and perspective changes, I use various skeletal points on the subject's body. Since the shoulders and pelvis are located directly over the legs, I draw axis lines across the top plane of the back where I can see the sharp corners of the skeleton come to the surface. This concept creates the front and back edges of the animal and a width that can then be compared to the vertical side of the creature's body.

5 **Portrait perspective** Using perspective and axis lines can give a really solid base for sketching the head and portrait. Use the back of the head and muzzle to find the length and width of your basic top surface perspective. Then, compare that with the vertical side of the head. That way, you can judge the correct proportions and the proper angle and perspective of the animal's head. The last step is to locate and run angle sights from the features on both side of the face. Organization is key to unifying your vision.

Finding balance

Something that is frequently overlooked when sketching animals is balance. The way an animal balances is key to showing the transference of the center of gravity in your sketch. Lose it and your animal will appear clumsy or wooden.

Tips to get you started

1 **Balance in action** Whether the animal is standing at rest or running as fast as the wind, there is a center of balance that should be inherent to your drawing. This relates mostly to animals that walk on four legs. Since the back legs produce the energy that is transferred to the front of the animal, the front legs are pillars supporting the chest. Two-thirds of a typical animal's weight is in the chest and shoulders. Draw them strong with clear forms and "feet."

2 **Swing and sway** Capture that energy that moves not only from back to front, but also from one side to another and back again. Exaggerate the twists and turns with a key line of action, and then break up the movement with lines of rhythm focused on the action. Where legs are moving, use overlapping, curving lines to display the anatomy in motion. If your subject is simply standing, find the one or two legs that are keeping the animal stable.

3 **Static balance** Balance doesn't just matter in drawings of standing creatures. Any animal that climbs, jumps, slithers or dives goes through a particular pattern of motions. The animal's body is formed from the demands made on it by its movements and function. When you

sketch, move back and forth over the image to give it a natural appearance, combining stability and movement. This concept covers primates climbing and swinging through trees, jumping horses and even applies to snakes creeping up branches.

4 **Balance and size** The size and weight of the animal is key to your artistic expression. The heavier the creature and the wider the distance between the feet, the more stable the animal's body on the ground plane. On the other hand, antelope and flamingos have longer legs and are high off the ground. Draw their legs with thin, active lines and not ponderous, heavy outlines, which will ruin your drawing's balance. Keep that "foot shape" clear and connected to the whole constructed sketch.

5 **Repeat your subject** Explore different methods depicting the interplay between the forms, action and stability of displaying balance. When quick-sketching subjects that are moving and shifting weight and balance, I find a good technique is to work on several drawings on one page at the same time, treating them as different short takes on animating the subject.

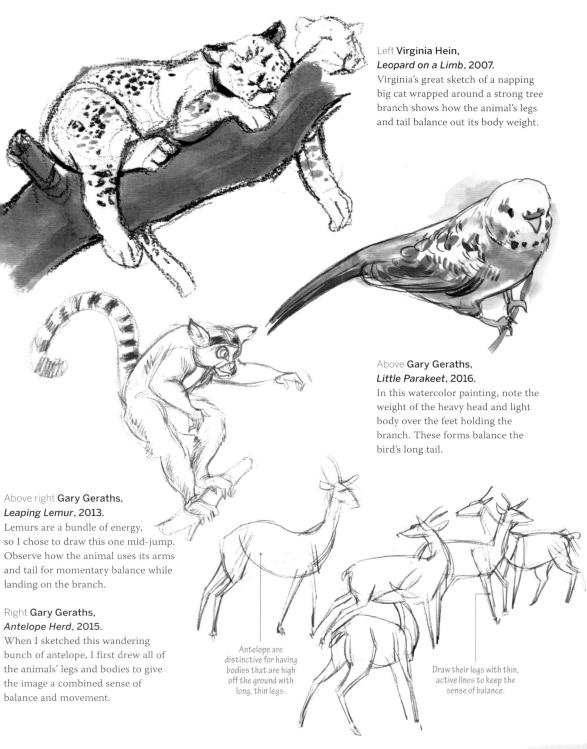

Left **Virginia Hein,**
Leopard on a Limb, 2007.
Virginia's great sketch of a napping
big cat wrapped around a strong tree
branch shows how the animal's legs
and tail balance out its body weight.

Above **Gary Geraths,**
Little Parakeet, 2016.
In this watercolor painting, note the
weight of the heavy head and light
body over the feet holding the
branch. These forms balance the
bird's long tail.

Above right **Gary Geraths,**
Leaping Lemur, 2013.
Lemurs are a bundle of energy,
so I chose to draw this one mid-jump.
Observe how the animal uses its arms
and tail for momentary balance while
landing on the branch.

Right **Gary Geraths,**
Antelope Herd, 2015.
When I sketched this wandering
bunch of antelope, I first drew all of
the animals' legs and bodies to give
the image a combined sense of
balance and movement.

Antelope are
distinctive for having
bodies that are high
off the ground with
long, thin legs.

Draw their legs with thin,
active lines to keep the
sense of balance.

31

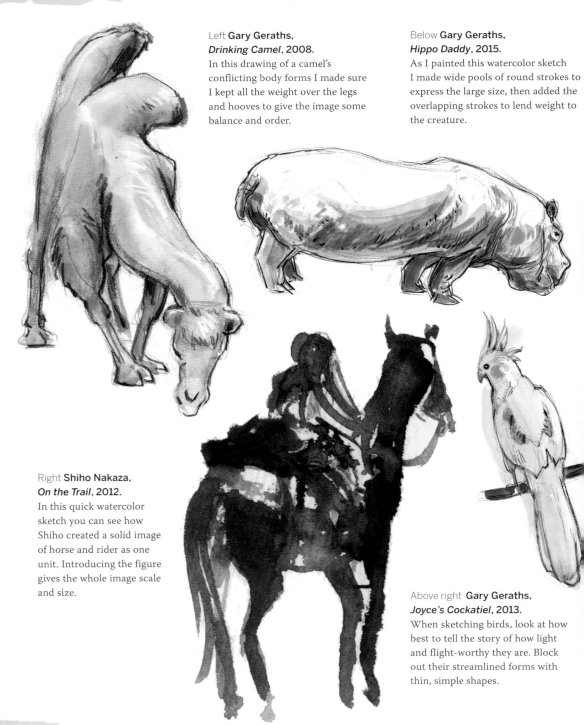

Left **Gary Geraths,**
Drinking Camel, 2008.
In this drawing of a camel's
conflicting body forms I made sure
I kept all the weight over the legs
and hooves to give the image some
balance and order.

Below **Gary Geraths,**
Hippo Daddy, 2015.
As I painted this watercolor sketch
I made wide pools of round strokes to
express the large size, then added the
overlapping strokes to lend weight to
the creature.

Right **Shiho Nakaza,**
On the Trail, 2012.
In this quick watercolor
sketch you can see how
Shiho created a solid image
of horse and rider as one
unit. Introducing the figure
gives the whole image scale
and size.

Above right **Gary Geraths,**
Joyce's Cockatiel, 2013.
When sketching birds, look at how
best to tell the story of how light
and flight-worthy they are. Block
out their streamlined forms with
thin, simple shapes.

Capturing size and weight

Every group of animals has a visual fingerprint of recognizable size and weight that makes their identity fairly obvious. The gesture, shape and proportion in your sketch will interact to differing degrees to graphically tell the viewer what the animal is, allowing you to flesh the drawing out.

Tips to get you started

1 **Big picture** When sketching animals there is a tendency to overdo the fur and hide, in the belief that the surface form and textures lend enough realism to a sketch to allow a casual observer to identify an animal. Instead, look at the subject's form and anatomy — these really give the animal its personality and impressional quality. A chaotic sketch of fur, feathers, wrinkly skin or other distracting elements can detract from character.

2 **Comparing subjects** Look at the anatomic size differences in your subject animal. A bull or oxen has a huge, upright upper body and neck contrasting a relatively small back hip. That comparison in a sketch makes for a dramatic statement. Compare and draw the size, proportions and weight of a squared-off draft horse and the size of a sleek, fluid quarter horse. Size and weight will lend character.

3 **Sculpting edges** When you first lay out the animal's size, it can be simplified to a flat shape. Graphically, that's a start, but now look at adding those simple core body volumes (tubes, boxes and so on) and push and pull them like a master sculptor. Round out some of the box edges, such as the wedges you see in the legs, or square up the edges of the cylindrical body "tube" as it meets the bony shoulders and pelvis. Note these contrasts and angular structure on the soft, weighty forms of a rounded body.

4 **Open your mind** Try not to have a preconceived idea about the outcome of your sketch. It's easy to fall into a formula or draw clichés. Look to how the animal moves and holds itself, the angle of its back, and from neck to head. Sharp lines may make the animal proud and alert. Curving, erratic lines over the line of action may give the drawing a heavy, distressed or old look. Remember that animals have a combination of lean muscle, bone, weighty muscle and fat areas.

5 **Light and dark** Light and dark shadow patterns fall and flow over your subject. The next step is to see and use a technique we discussed earlier — the silhouette. This establishes the true shape, but the light and dark size patterns change across the animal as they move over sharp or soft tissue forms. These light/dark patterns can also be simplified into puzzle shapes. This reinforces the gesture, weight and mass of your artwork.

Drawing paws and claws

The feet and legs of animals can get overlooked in sketching. When drawn correctly, attaching paws and feet will give your image a real punch and help define the animal's character. The feet, even when quickly and abstractly sketched, give the subject a sense of jumping, running, standing and balance. Practice these techniques and you will lend power to your images.

Tips to get you started

1 **Lots of feet** Drawing animals with paws and claws encompasses a variety of subjects. This topic covers a lot of territory and is meant for drawing big and little cats, big creatures, dogs, rabbits, rodents, bears, raccoons and so on. Animal paws mirror human hands and feet in construction. Many creatures stand on the very tips of their fingers and toes. If you are flexible in applying these methods as you speedily draw, it makes for an exciting and solid image.

2 **Dog paws** Just because you are focusing on sketching the paws of an animal doesn't mean that you can forget they are attached to its legs or "arms." Learning the skeletal framework helps inform where that gestural layout goes. Then you can notate the shape and size of the paw to establish the animal's proportion and the ground plane it's attached to. Draw dogs with a small, shell-shaped pad, with simple, hooked, angular toes, to start your design.

3 **Plantigrade feet** Bears, raccoons and many rodents and squirrels walk and rest on flat feet, like humans do. Observe how the paws look like wooden planks. Out of the square end come oval toes and hooked claws. This structure can

be adapted and drawn for rodent-like animals, such as ferrets, squirrels and even rats and hamsters. Practice abbreviating and quickly sketching in the spirit of how it looks on the smaller animals.

4 **Cat paws** When you sketch cats — large and small — the feet and claws are important in nailing down their character and actions. Start by visualizing front and back paws as thick scallop shell forms. Then, scoop out the top of the "shell/paw," forming a dent where the leg bone comes down to the toes and retractable claws. Draw these digits as soft, angled boxes. Add a separate thumb and the dark, defined, rounded paw pads.

5 **No floating animals** When you are quickly sketching animals, you are trying to attach your creature to the ground. In short, add a little cast shadow mark under the foot — no more than a simple horizontal dash — to anchor your image to a ground plane. Hint at the environment and maybe put a few splashes of grass around the foot. (This can make for a spot of camouflage if you mess up a foot!)

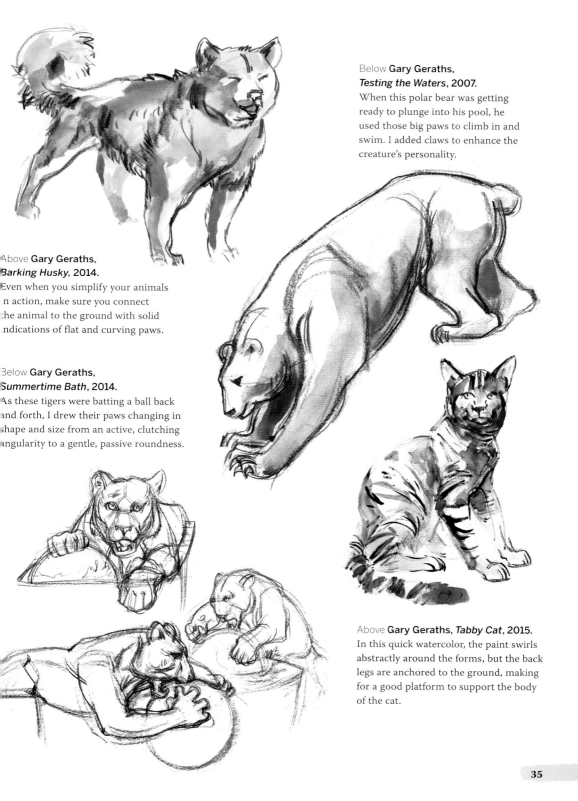

Below **Gary Geraths,**
Testing the Waters, 2007.
When this polar bear was getting ready to plunge into his pool, he used those big paws to climb in and swim. I added claws to enhance the creature's personality.

Above **Gary Geraths,**
Barking Husky, 2014.
Even when you simplify your animals in action, make sure you connect the animal to the ground with solid indications of flat and curving paws.

Below **Gary Geraths,**
Summertime Bath, 2014.
As these tigers were batting a ball back and forth, I drew their paws changing in shape and size from an active, clutching angularity to a gentle, passive roundness.

Above **Gary Geraths,** *Tabby Cat*, 2015.
In this quick watercolor, the paint swirls abstractly around the forms, but the back legs are anchored to the ground, making for a good platform to support the body of the cat.

Hooves, pads and feet

The defining aspects of many animals, large and small, are the hooves and feet. There are a huge variety of different sizes and shapes in this topic, but keep your cool. If you know how to combine shape, simple volumes and gesture, you will draw with fluidity and confidence.

Tips to get you started

1 **Figuring it out** There are a wide array of subjects here, from massive elephants to tiny impalas and gazelles. First, look at the width of the lower leg of the animal. For the most part, this is easy to see in that most of the muscle volume stops close to the torso. Break your lines down into a pipe and ball arrangement with a wedge for the end of the hooves. As you practice drawing, you will learn to adjust your approach to the size and weight of the subject.

2 **Grounding that hoof** The majority of hooves are flat in the back. Use the front portion of the hoof to point the foot and legs in the direction the animal is moving. Once again, the hoof is connected to the leg with tubes representing the bone shaft and a block or ball for the "ankle." As a horse moves or lands a jump, build a squared off "heel" to help balance out the weight on the hoof. Establishing the animal's balance is important.

3 **Expressive marks** Many of the creatures you will sketch will have split hooves. These include cattle, giraffes, antelope, gazelles, deer, elk and even llamas and camels. The general appearance is a triangular cleft in the front of the hoof with sharp points at the front tips.

The expressive quality in your line and tone will help anchor the hoof. Depending on the animal's size and weight, it will be shown with a dark, thick line or thin shafts of tone.

4 **Camels and llamas** These animals are unique when drawing feet and paws. Because of the terrain camels wander (sand and rocky slopes), their feet are constructed to adapt to soft and hard surfaces. Drawing the tube and ball construction works beautifully, but at the ankle, it breaks into two forked toes. There is a solid pad in the back but, off that, two triangular tubes emerge with a sharp, triangular toe at the tip. Llama feet are slimmer; they walk on their toes as if they are standing in high-heel shoes.

5 **Little hooves** Last but not least are smaller animals like goats, sheep and pigs. These animals' legs and hooves are lined up vertically over the hips. When it comes to sketching, the hooves can be treated like upside down pyramids or small, thick blocks. Draw the sharp edge of the wedges toward the direction the animal is walking. Don't let the lines get soft and mushy because it's all bone and hoof, which means angular, sharp lines and tones.

Below Gary Geraths,
Feisty Warthog, 2016.
Every hooved animal has its own toe shape and covering. Draw them with character and strength to support the creature.

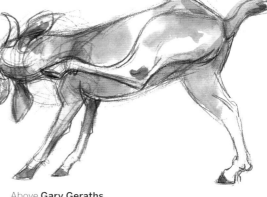

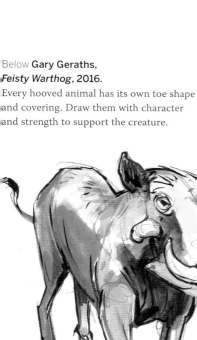

Below Holly Overin,
Long Winter Coat, 2010.
This takin's heavy body weighs down on those splayed hooves as it grazes. The hooves and feet are shown supporting the creature's weight and action.

Above Gary Geraths,
Elephant Walk, 2008.
I drew this elephant with a sense of purpose and action. I sketched the pads rounded in the air but flattened when putting weight on the ground.

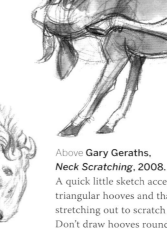

Above Gary Geraths,
Neck Scratching, 2008.
A quick little sketch accents the goat's triangular hooves and that thin leg stretching out to scratch a pain in his neck. Don't draw hooves rounded and soft.

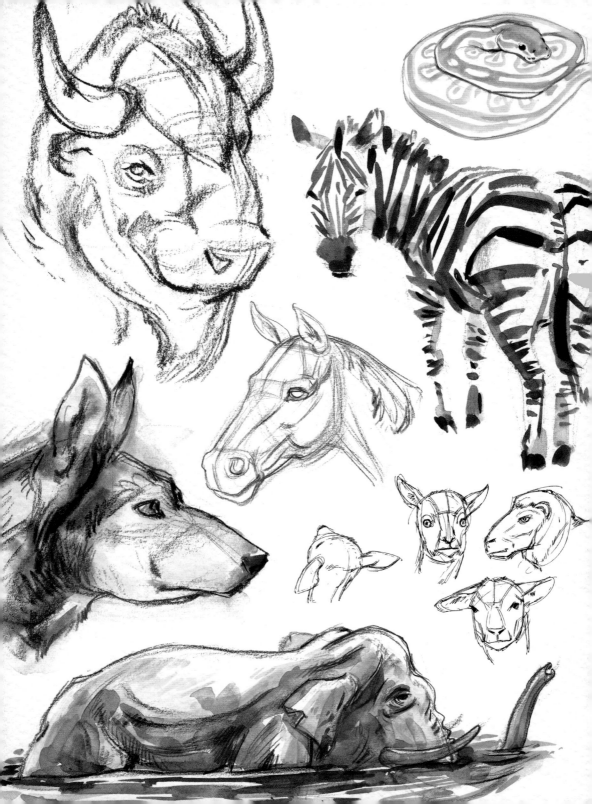

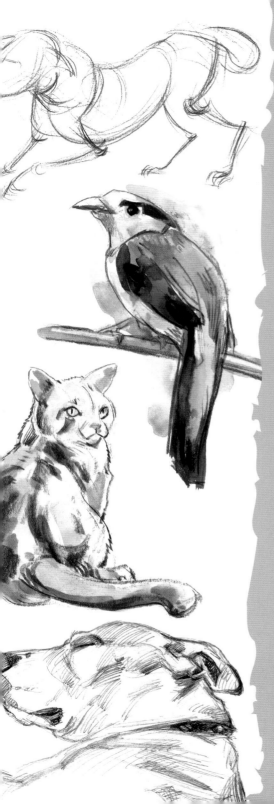

2

Pulling the pieces together

As the chapter title implies, these topics deal with adding form, personality and surface textures to your creature's basic structure. These tips will give you the confidence to create a stack of drawings, as you move from one kind of animal to a completely different one. We will start with a simple skeletal framework, then move on to designing the forms and various basic animal heads and features. These breakdowns will allow you to quickly create solid "portraits" that will complement your drawings. To tie all of this visual information together, we'll then jump into covering animals in a wide array of fur, hides and feathers and give your sketches vitality and expression. The aim is to be able to tell a story about your subject animals while at the same time learning to confidently and swiftly sketch with focus.

Left The more you draw, the more you understand and build up knowledge of structure and surface, which makes for solid, exciting sketches and great portraits with great form.

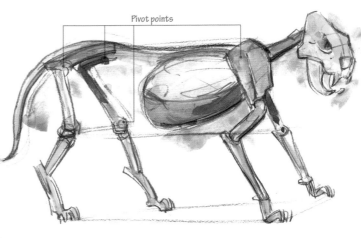

Pivot points

Right **Gary Geraths,**
Lion Skeleton, 2016.
Compare and contrast the structural elements in the various skeletons you look at. Learn to reduce the basic forms and joints to simple shapes and pivot points.

Below **Gary Geraths,**
Playful Dog, 2007.
It's amazing how simplified you can make your animal using just a linear skeleton, and still fill it with character and action. Try introducing a sense of transparency to the process.

Below **Gary Geraths,** *Bird Skeletons*, 2014.
When I study and sketch skeleton forms, it doesn't result in a tiresome rendering of bones. A light, fast and yet focused approach to the mechanics pays off in knowledge.

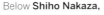

Below **Shiho Nakaza,**
Running Horses, 2015.
Shiho manages to make these skeletons from the Natural History Museum very animated, as if they are galloping through the gallery. The lines give the drawing implied gesture and movement.

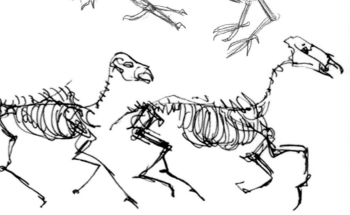

Understanding the skeleton

Like the hard-framed chassis of a car, the skeletal structure of
animals cannot be readily seen, but it holds everything together. With
study and understanding, you can bend and adjust the framework and animate
your drawings successfully. Remember — it's not just a bag of bones but
a subject to draw quickly and to give a freshness to.

Tips to get you started

1 **Simplified skeleton** First of all, it's best not
to think of the skeleton as a bunch of separate
bones. It's better to visualize it as a fluid
framework that bends and twists, yet gives
a strong structure to hold up and support
the weight and movements of your subjects.
Sketch with searching lines that trace the line
of action.

2 **Dynamic framework** The skeleton is a fairly
rigid scaffolding that the muscles attach to at
specific spots. That means you can count on
the various animals' proportions being really
consistent. As you draw, you can always fall
back on those repeatable measurements as
you search and sketch.

3 **Profile proportions** A great way to get a handle
on starting your sketch is to look at how the
profile of the spine and head work together.
Horses' backs bend up into the head, but cow
spines are flat and the neck bends down into
the head. Cats's spines have a curving profile

into a rounded head. A dog's spine sit straight
into an angular head. Push that line to reinforce
the animal's changing form.

4 **Surface landmarks** Though a lot of the
skeleton is buried under hide and hair, you
can still see the skeletal landmarks poke up on
the surface. These are pivot points at the hip,
shoulders and legs, and usually show where
the body form moves or changes direction.
You can see these spots by looking for angular,
shadowed points on the surface and accent
them with dashes and dark marks.

5 **Adaptable sizes** Remember when the drawing
gets tough and confusion edges into your
process that all animals have similar skeletons.
This is a key organizing principle. Creatures that
vary in size, from hamsters to brontosaurs, all
carry that same organic framework and form.
Study and learn the general layout and how it
works. This will help you organize your thought
processes and give you a solid image.

Quick head structures

Later in the book we'll be exploring additional methods of drawing animal heads and portraits, but this is an important starting point. Design and speedy layout are essential to giving your sketch a personality and lending an individuality to your animal's head. You must also be able to draw athletically with confidence and an accurate hand.

Tips to get you started

1 **Skull as structure** A great deal of the animal portrait you will draw will rely on the form and function of the skull to give you the personality and proportions. In fact, it's the combination of drawing flat shape and solid form that will help identify the kind of creature you are sketching. Search for the front and side planes to show which direction the animal is facing.

2 **Proper proportions** As you quickly sketch, you will notice a lot of similar aspects to almost all of the animals you draw. If you aren't careful, your sketch of a lion can quickly turn into a bear or dog merely by narrowing or shortening the nose. Locating the features correctly on the top or side of the head is important to get right. Make sure you use those as lines and notations to place everything where it should be.

3 **Lumps and bumps** You will be using just about anything possible to get your portrait set up right, so don't forget that bony skull structures give you angular bumps, eye sockets, jaw shapes and so on. These features can be used to line up the correct proportions and even help create a shadow pattern to give your subject a unique look.

4 **Back of the head** As the animal moves around, the most dynamic angle might be from under, over or a back view. That sets up a new set of rules in that the neck becomes the focus, partly obscuring the ears and jaw. Practice drawing the back of the jaw and head as a square box the neck overlaps and fits into. Then locate the ears where the forms fit together. Draw an axis line between the two locations to anchor them in the right place.

5 **Horns and antlers** The same goes for horns and antlers — no matter what angle you draw them from. Frequently, the ears, horns and antlers are located right next to each other and really need to be organized so they don't clash. It's best to design antlers, frequently located over the ears, by putting in a couple of axis lines and rounded lines to give them form and establish points on the head.

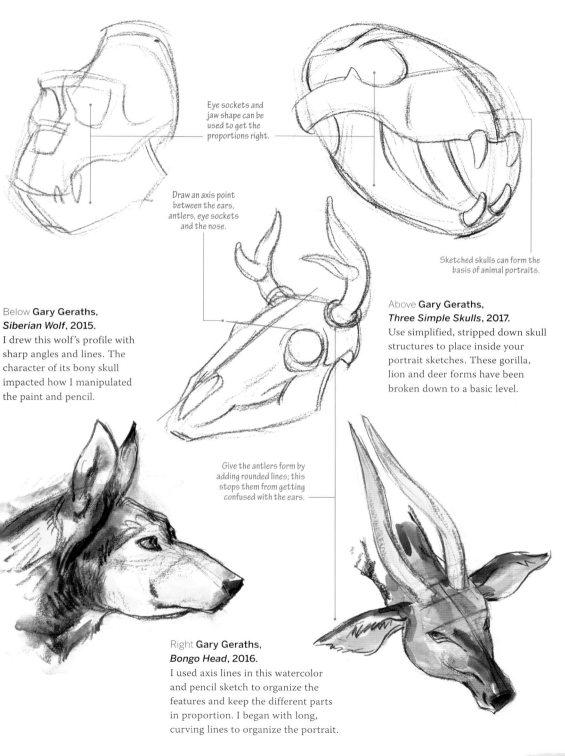

Eye sockets and jaw shape can be used to get the proportions right.

Draw an axis point between the ears, antlers, eye sockets and the nose.

Sketched skulls can form the basis of animal portraits.

Below Gary Geraths, *Siberian Wolf*, **2015.** I drew this wolf's profile with sharp angles and lines. The character of its bony skull impacted how I manipulated the paint and pencil.

Above **Gary Geraths,** *Three Simple Skulls*, **2017.** Use simplified, stripped down skull structures to place inside your portrait sketches. These gorilla, lion and deer forms have been broken down to a basic level.

Give the antlers form by adding rounded lines; this stops them from getting confused with the ears.

Right **Gary Geraths,** *Bongo Head*, **2016.** I used axis lines in this watercolor and pencil sketch to organize the features and keep the different parts in proportion. I began with long, curving lines to organize the portrait.

Sketching heads — cats

Among the most beautiful, powerful and yet delicate of creatures'
heads are cats' heads. These can encompass everything from a massive
lion head to elegant servals and cute kittens. Capturing the structure
and personality of these creatures takes practice and the willingness
to take chances in your drawing methods.

Tips to get you started

1 **Form and skull** Learning to sketch the basic
ovoid form and shape are paramount. The skull
and muscle-filled cheekbone are the primary
forms with a blunt, squared off muzzle filled out
and supported with thick, sharp teeth. Make
sure you compare the top panel of the forehead
and muzzle with the vertical jaw and mouth and
draw them in together.

2 **Where are those eyes?** As you quickly lay out
the head in your design, make note of placing
the eyes about two-thirds up the head. They
should be round eyes in round sockets with a
pie-shaped opening where they look forward.
Be careful to get the eyes the right size. House
cats have bigger eyes, while big cats have brows
that make their eyes appear smaller.

3 **Big teeth** It's easy to get lost in that big upper
part of the head, so contrast that with a fairly
squared off nose area, which forms a right
angle at the tip. The nose is rather triangular,
with a "Y" that attaches to the upper lips. Make
sure your sketch has expressive lines that catch
the soft proportions of the side of the mouth
and those rows of sharp teeth.

4 **Ears for hunting** Located on a line that
extends from the nose through the eyes and
to the top of the head are the ears. Draw them
as rather shell-shaped forms with tuffs of hair
on the insides. House cats tend to have pointed
ears; big cats' are rounded. Make sure you draw
them with curving lines at the base so they
attach to the head.

5 **Dynamic lines** The character and variety
of your line and tone should bring out the
personality in your creature portrait. Run
a galaxy of marks around your subject's
head. The more angular the marks, the more
threatening the portrait looks as you build it up.
Likewise, if everything is rounded, it appears
soft and passive. Study and draw a diverse set
of intertwining lines and values to create a
dynamic character.

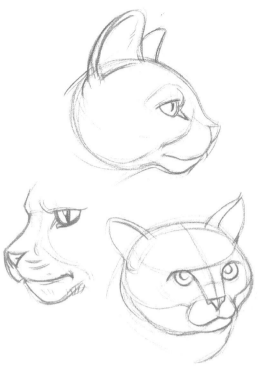

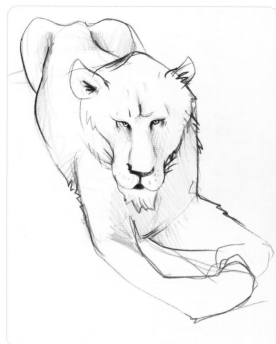

Above **Gary Geraths,**
Simple Portrait Design, 2015.
Instead of focusing on texture and detail,
I drew through and around the form of
our house cat's head. This shows how
the volumes and features work in tandem
when designing a portrait.

Above right **Nikolai Drjuchin,**
Long Faced Gypsy, 2015.
With a few lines, the artist managed
to create an accurate, wonderful
character sketch of a lion with
exaggerated proportions but still
an evident lion appearance.

Right **Gary Geraths,**
Snarling Lioness, 2013.
Using a basic big cat head structure,
I stretched the face into a focused, angry
beast. Don't be afraid to push and pull
the features around to match the
animal's expression.

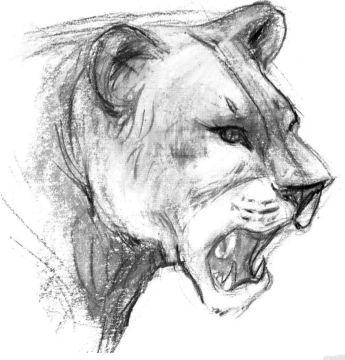

Sketching heads — dogs

When dealing with the subject of sketching dogs' heads and portraits, there is a vast array of different methods you can deploy in laying down marks to convey the expressional qualities. Once you become acquainted with these methods, drawing a dynamic canine portrait will become easier and lead to an image with more of a visual impact.

Tips to get you started

1 **Lots of choices** The varied shapes and form combinations of dogs' heads — round, angular, long snouts, sharp and long floppy ears, etc. — are fascinating. These shapes and lines mix together to produce the animal's character. Sketch out the head structure in a similar manner to that discussed in earlier topics, and expand on the expressive qualities to build a solid character study.

2 **Shapely eyes** When building up the head, placing the eyes is important, so just make a little note — even a couple simple dots on the page. The eyes are generally placed about a third down from the top of the head. The area around the eyes is accented by cheekbones that curve to the back of the head, with a good brow that can be drawn to focus attention on the personality and character.

3 **Muzzles** While the structure of the muzzle is similar across the vast variety of dogs, there is also room for expression. The marks you use will push the idea of tight skin over the teeth, or huge, sloppy pads hanging off the nose and back into the cheeks. The nose is box-like, with two big curves coming in from the sides. Sketch the longer part of the mouth as sharp and angular.

4 **Spiky and floppy ears** As dogs move and play, their ears really come into effect as a way of showing movement and character. Draw the various shaped ears and then join them to the upper part of the head. The outer part of the ear is curved and located in line with the joint of the upper and lower parts of the jaw. You should use an array of marks to show the overlapping forms and strong, angular cartilage.

5 **Head and neck** There are so many different shapes and forms when drawing dogs' heads, but you should still draw with a common knowledge of the structure. This gives you a base that allows you to adapt to different proportions in your design. Try sketching the expressive marks in the head down into the body and connect them as one whole unit. Look for that natural flow of rhythm.

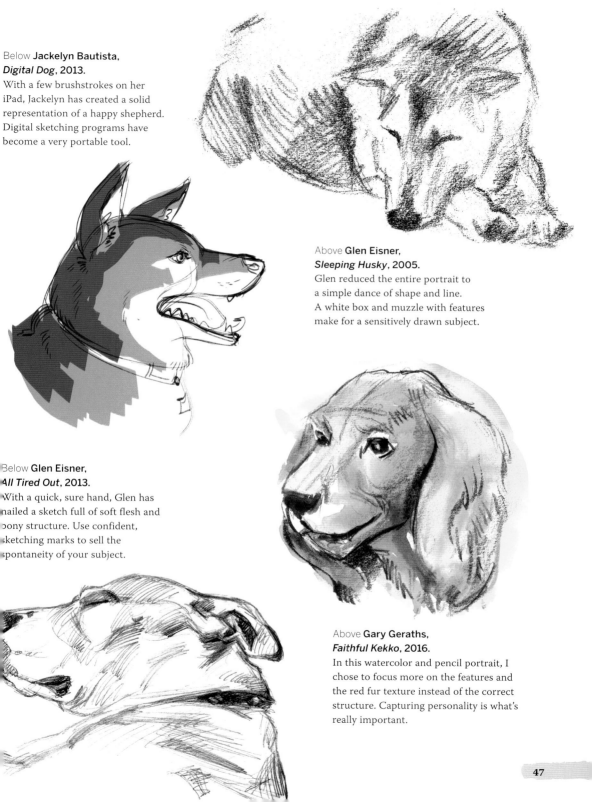

Below **Jackelyn Bautista,**
Digital Dog, 2013.
With a few brushstrokes on her
iPad, Jackelyn has created a solid
representation of a happy shepherd.
Digital sketching programs have
become a very portable tool.

Above **Glen Eisner,**
Sleeping Husky, 2005.
Glen reduced the entire portrait to
a simple dance of shape and line.
A white box and muzzle with features
make for a sensitively drawn subject.

Below **Glen Eisner,**
All Tired Out, 2013.
With a quick, sure hand, Glen has
nailed a sketch full of soft flesh and
bony structure. Use confident,
sketching marks to sell the
spontaneity of your subject.

Above **Gary Geraths,**
Faithful Kekko, 2016.
In this watercolor and pencil portrait, I
chose to focus more on the features and
the red fur texture instead of the correct
structure. Capturing personality is what's
really important.

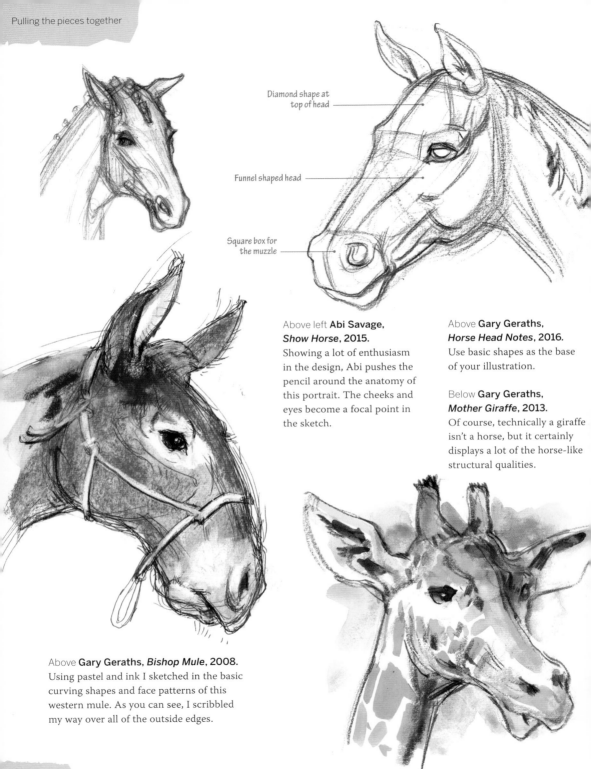

Diamond shape at
top of head

Funnel shaped head

Square box for
the muzzle

Above left **Abi Savage,**
Show Horse, 2015.
Showing a lot of enthusiasm
in the design, Abi pushes the
pencil around the anatomy of
this portrait. The cheeks and
eyes become a focal point in
the sketch.

Above **Gary Geraths,**
Horse Head Notes, 2016.
Use basic shapes as the base
of your illustration.

Below **Gary Geraths,**
Mother Giraffe, 2013.
Of course, technically a giraffe
isn't a horse, but it certainly
displays a lot of the horse-like
structural qualities.

Above **Gary Geraths,** *Bishop Mule*, 2008.
Using pastel and ink I sketched in the basic
curving shapes and face patterns of this
western mule. As you can see, I scribbled
my way over all of the outside edges.

Horse-like head structures

When we think of horses, in reality this covers a wide range of creatures — from giraffes to antelope to zebras — that have the structure of the horse as their base model. Diversify your methods and sculpt the basic forms — the possibilities in your drawing are endless.

Tips to get you started

1 **Triangular head** Since the horse head is relatively long, it can be easy for your sketching proportions to get out of control. Put the emphasis on seeing the big forms: a funnel shaped head, a diamond shape on the top of the head, and a square box with a slightly angular tip for the muzzle and mouth.

2 **Big eyes** When sketching the areas around the upper portion of the horse's head, lay in the large, rounded eyes with some lightly jabbed marks. Also, make sure you get the distance between the eyes right, with an axis line from one side of the head to the other about a third of the way down the head. Also, don't forget to draw those big, thick, curving eyelids to accentuate the beauty of this animal's face.

3 **Elastic mouths** Use long, straight lines to sketch in the shape of the head, then when you get to the muzzle and mouth, look for an angular, triangular tip where the mouth turns down in the curving corner. The nostrils should be big and rounded and the lips full. These features can be drawn with strong, angular and curving lines expressing the bone, teeth and elastic corners of the mouth.

4 **Spear ears** Block in that flat, large, U-shape of the jaw with authority and purpose to make the horse look strong. Above the jaw are expressive ears that stand up like a pear and twist around. When placing them at the back of the head, create sockets the ears will fit into. Draw pointed forms and curving cartilage.

5 **Diversity of subjects** The fun part of drawing horses is being able to use the basic head-drawing methods, tweaking the shapes and forms to sketch various animals with similar head characteristics. Widen or narrow the proportions and you can sketch a giraffe or many kinds of antelope. Shorten the nose and widen the jaw and you'll be confidently drawing a zebra. Be fluid and look for changes in the basic horse head shape.

Cattle-like head structures

From rugged rhinos to delicate gazelle, you can see the
similarities between the head structures of these animals and those of
cattle. With careful observation, you will learn how the strong angles and
forms can be pushed and pulled with pencil and paint into many
different, realistic and dynamic portraits.

Tips to get you started

1 **Blocky skulls** Look at the big square mass
of the basic cattle skull. That head is built of a
square jaw, a flat top of the forehead and a boxy
muzzle. Draw lots of angles and corners for the
big mass of the upper head. Next, look at the
narrow center section that anchors into the
square nose. You can see a strong triangular
shape in the profile.

2 **Big eyes** When drawing the eyes, remember to
place them about two-thirds up the head. On
cows, eyes are positioned out to the side of the
skull to be able to scan for predators. Draw the
eyes with a prominent brow and a long, angular
cheekbone. Then, sketch a big, round eyeball
and cover it with a thick set of eyelids. It doesn't
matter if it's a thinner, more delicate gazelle or
antelope; the process can be adjusted to fit
your subject. It's actually a fun challenge to
fluidly adapt to a new animal.

3 **Mouth and nose** Now move on to the nose
and mouth to sketch that square muzzle.
To begin, box the muzzle out from the slightly
narrowed nose bridge. Cattle-like animals
spend a lot of time chewing their food, so have
a heavy, square set of teeth that give the mouth
form. At the back of the mouth there are also

thick skin overlaps, with flaps on the horizontal
crease of the lips. Sketch in horizontal comma-
shaped nostrils as a landmark. With animals
like rhinos and giraffes, there is a triangular tip
on the end of the upper lip.

4 **Head gear** A lot of character happens at the
summit of the head. As you quickly sketch the
ears, don't forget to add the horns or antlers
(for moose, deer, etc.) in your design. Think of
the horns and ears as being attached to the
head as if twisted like a light bulb into a socket.
The ears are generally triangular cup shapes
with pointy tips. Getting all of these forms right
can be tricky, so it's best to run a couple of axis
lines from one side to the other to keep
everything symmetrical and in proportion.

5 **See the big picture** Sketching animals with
cattle-like appearances and forms covers a
lot of ground. With your pencils and brushes,
you can create many variations off the basic
template of the cow head. A great technique is
to compare and contrast the height of the back
jaw against the narrow size of the mouth. Rid
yourself of the features and make sure the
shape and form are true.

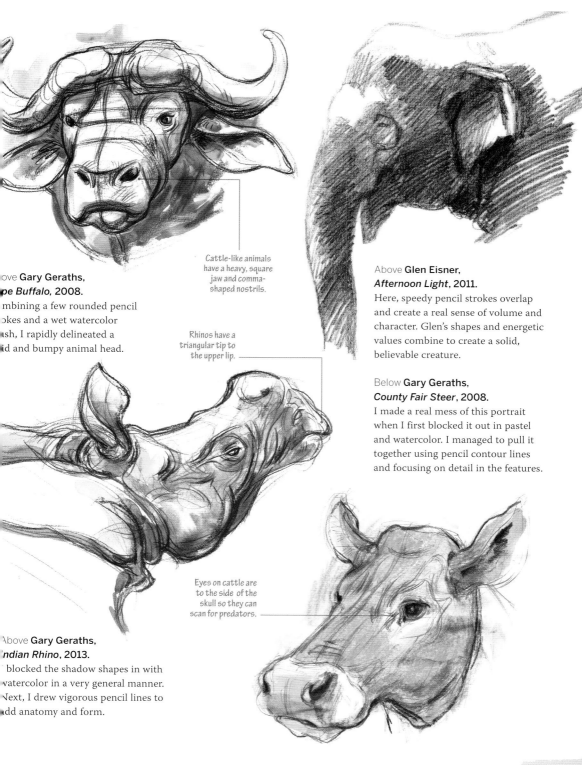

Cattle-like animals
have a heavy, square
jaw and comma-
shaped nostrils.

ove **Gary Geraths,**
pe Buffalo, 2008.

mbining a few rounded pencil
okes and a wet watercolor
ush, I rapidly delineated a
d and bumpy animal head.

Rhinos have a
triangular tip to
the upper lip.

Above **Glen Eisner,**
Afternoon Light, 2011.
Here, speedy pencil strokes overlap
and create a real sense of volume and
character. Glen's shapes and energetic
values combine to create a solid,
believable creature.

Below **Gary Geraths,**
County Fair Steer, 2008.
I made a real mess of this portrait
when I first blocked it out in pastel
and watercolor. I managed to pull it
together using pencil contour lines
and focusing on detail in the features.

Eyes on cattle are
to the side of the
skull so they can
scan for predators.

Above **Gary Geraths,**
ndian Rhino, 2013.

blocked the shadow shapes in with
watercolor in a very general manner.
Next, I drew vigorous pencil lines to
dd anatomy and form.

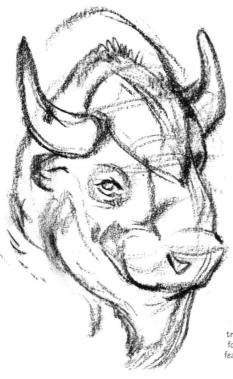

**Left Gary Geraths,
Yellowstone Bison, 2011.**
When you are drawing wild
animals, you need to get the
essentials down fast. In this
pastel sketch, I worked up the
features and forms together,
knowing that I could add
textures later if needs be.

**Below Gary Geraths,
Little Lambs, 2009.**
Quick sketching isn't a perfect
science. In these portraits the
features look both quirky and
yet still solid. Remember, not
every drawing has to be a jewel.

Use a simple
triangle as a base
for keeping all the
features together.

**Below Alexa Nakamura,
Tumbleweed, 2016.**
This little character sketch of an owl
shows the spirit of focusing on the
unique features of certain animals.
Use those exaggerated features to
tell the subject's story.

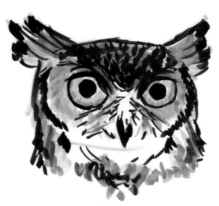

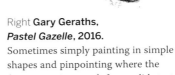

**Right Gary Geraths,
Pastel Gazelle, 2016.**
Sometimes simply painting in simple
shapes and pinpointing where the
features go is enough for a solid start.
Here, I added dynamic edges and
features with thick and thin lines.

Creature features

There are a multitude of differences between the thousands of different faces in the animal world, but there are also a great many similarities that link their features together and give you sketching solutions. With practice, you will learn to get your creature portraits right every time.

Tips to get you started

1 **Simple and right** It helps to have an organizing technique that you can rely on. In putting all the features together and keeping them in place, you can fall back on using a simple triangle as a base. The wide portion of the shape can be placed across the ears or eyes. The sharp point can be drawn down at the nose or mouth, or even the tip of the chin. The triangle widens or narrows depending on the facial proportions.

2 **Bull's eye** When sketching at speed, the best focal points are the eyes. Here it's a case of accenting the areas around the eyes to bring out their character. First, nail down the shape of the eye — rounded, triangular, oval? Use the brow, thick eyelids and even the tear ducts to help form the eyeball. With birds and small creatures, there are protective rims and ridges that surround the eye. Other animals have bags and heavy lids that can express character, personality and age.

3 **Mouth shapes** At the bottom point of the organization triangle are the mouth, nose, muzzle, beak or trunk. Locate the mouth and nose with quick strokes covering all the sides and proportions, but define the character and expression with different line. Noses are

triangular, square or oval and have a sharp vertical dash that connects them to the pads that cover the teeth. Mouths are elastic and can be stretched and compressed with thin and thick lines. You can animate the whole face with just a couple of quick, authoritative lines.

4 **Antlers and pipes** Horns, antlers and ears fill up a creature's crest like a crown. Antlers and horns can be simplified into short sections of connected pipes, welded together with overlapping lines and fluid shadows. Ears help frame an animal's face, varying in size from little twitchy nobs on chinchillas to tall antennas on jackrabbits. Draw them in various directions to see what makes the most impact graphically.

5 **Short exercises** To strengthen your sketching techniques, draw a wide array of creature heads, large and small, to compare and contrast the shapes, forms and features working together. Sketch the heads from several various angles — even the back of the head — and do it on the same page so you can see if your proportions are clear and correct. Sketch a rhino's head structure next to a gorilla's, and don't be surprised if you see connections between them.

Simple surface and texture

At this point, all of the animal drawing techniques you've learned will come into play. You'll be building on and expanding your range of line and tone to create the illusion of shiny fur, surface form, spiky protective coats or hundreds of other textures, from smooth and leathery hides to soft and beautiful coats.

Tips to get you started

1 **Organizing detail** It's important not to get lost in all the flash and detail when drawing surface form and texture. Think back to the organizing methods of expressive shape and measured forms so that your sketch will be recognizable. These qualities will give your drawing an identifiable base on which to apply creative textural sketching to add to your design.

2 **Surface drawing** Now is when you start to really use the huge variety of media at your disposal to combine movement, structure and texture with drawing materials to communicate the personality of your subject. Use watercolor to suggest a smooth coat, colored pencils to lay down some smooth shapes or suggest feathers, ink and pen marks to suggest a thick coat. Only your imagination can limit you.

3 **Texture design** You won't have a lot of time to render details; they will only distract the viewer, so simplicity is key. Design the surface textures so they enhance your design. Don't entirely cover the face and feet of your subject. Use the form and anatomy, don't obscure it. All coats and hide textures have a growth pattern and shape to them. Find the direction and character of them and block them in quickly. Then, draw the exterior contour and interior texture at the same time. It makes for a dynamic statement.

4 **Thick skin** Some animals you draw will have nothing but a tough, thick hide and wrinkles. Combine your lines and tones into a mixture of angular and rounded marks. Those marks will move your eye around and over the animal's body. Tell a story with your drawing about the animal you are looking at. Does it have thick, folding, armored skin like a rhino, or a smooth, glistening body like a hippo? The expressive quality of your marks will build a visual story.

5 **Action shapes** Some animals have thicker, fuller hair coats than others, such as dogs, bears, some cattle-like creatures and small pets like chinchillas and cats. Dogs especially love to run and play, and that hair goes flying all over the place. When you draw all that action, keep the smooth shapes and fluid lines toward the front of the animal. Place the more jagged lines showing the texture of the coat at the back of the forms. Try and limit the number of strokes and keep the marks simple so they don't distract from the animal's form. Remember to make your statement clear and let the viewer's imagination fill in the details.

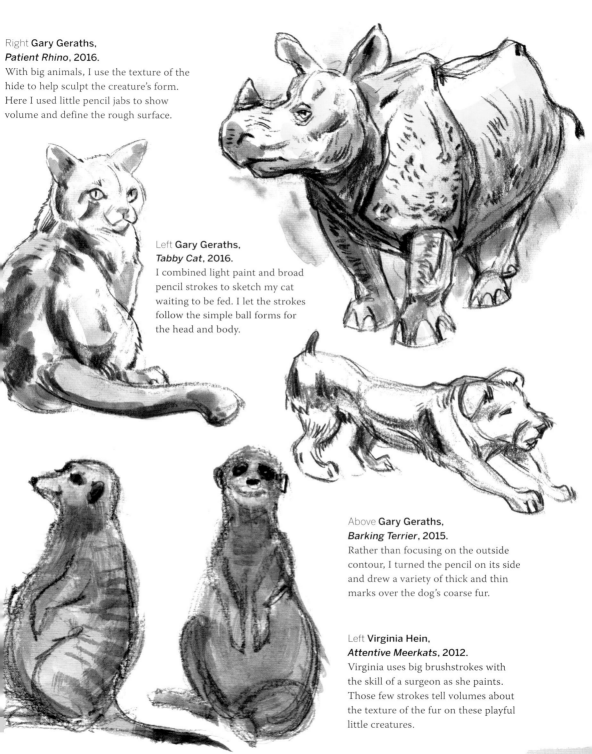

Right **Gary Geraths,**
Patient Rhino, 2016.
With big animals, I use the texture of the hide to help sculpt the creature's form. Here I used little pencil jabs to show volume and define the rough surface.

Left **Gary Geraths,**
Tabby Cat, 2016.
I combined light paint and broad pencil strokes to sketch my cat waiting to be fed. I let the strokes follow the simple ball forms for the head and body.

Above **Gary Geraths,**
Barking Terrier, 2015.
Rather than focusing on the outside contour, I turned the pencil on its side and drew a variety of thick and thin marks over the dog's coarse fur.

Left **Virginia Hein,**
Attentive Meerkats, 2012.
Virginia uses big brushstrokes with the skill of a surgeon as she paints. Those few strokes tell volumes about the texture of the fur on these playful little creatures.

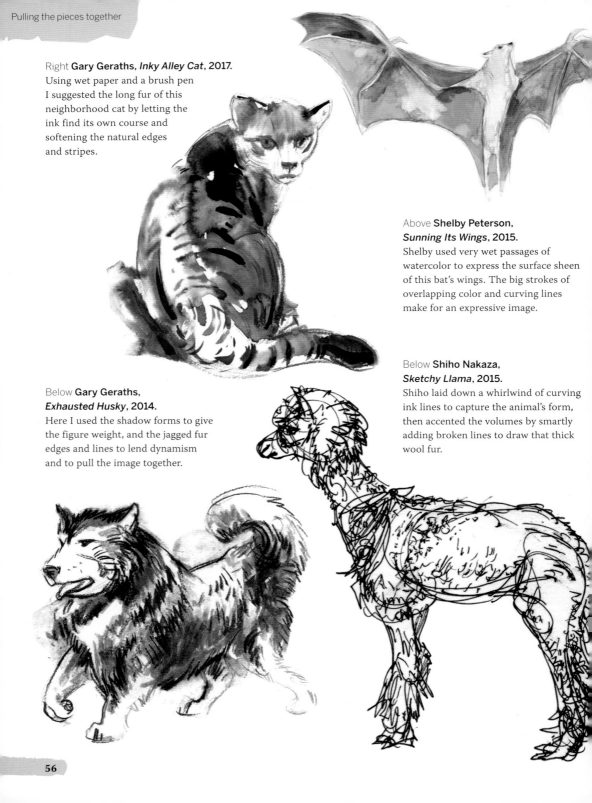

Right **Gary Geraths,** *Inky Alley Cat*, 2017.
Using wet paper and a brush pen
I suggested the long fur of this
neighborhood cat by letting the
ink find its own course and
softening the natural edges
and stripes.

Above **Shelby Peterson,**
Sunning Its Wings, 2015.
Shelby used very wet passages of
watercolor to express the surface sheen
of this bat's wings. The big strokes of
overlapping color and curving lines
make for an expressive image.

Below **Shiho Nakaza,**
Sketchy Llama, 2015.
Shiho laid down a whirlwind of curving
ink lines to capture the animal's form,
then accented the volumes by smartly
adding broken lines to draw that thick
wool fur.

Below **Gary Geraths,**
Exhausted Husky, 2014.
Here I used the shadow forms to give
the figure weight, and the jagged fur
edges and lines to lend dynamism
and to pull the image together.

Fur in a hurry

Being able to abbreviate and quickly communicate hair and fur coverings in your animal sketches is paramount. Furiously sketching a moving (or even static) animal takes a lot out of you as you run from one solution to another. Learning how to edit complex textures and color markings can give your image an exciting and sophisticated appearance.

Tips to get you started

1 **Simple strokes** Practice using your whole arm when you first block in the fur coat. Use a few quick flicks of the pencil to add the hair design of your subject. Rather than thinking of the fur as a separate element, sketch the coating's character first. Use the side of the pencil with wide, curving strokes to form soft, puffy planes and shapes. Straighter and slightly curving lines will imply fur over taut muscle forms.

2 **Color patterns and spots** One danger when sketching animals is allowing spots and colored shapes to take over your image. We will examine "dynamic markings" in the next topic, but bear in mind that no matter how bright, stunning, colorful or unique the markings are on any creature, they must take a back seat to the subject's form and character. That rule can be flexible when sketching colorful birds because the colors are flat and reinforce the shape, but all the same — edit, edit, edit for success.

3 **Long hair, short hair** A good deal of an animal's personality comes from the character of its fur coat. Random pencil strokes may give your subject a wild, natural look. Another animal drawing may need a series of groomed, organized strokes to tell a different story. All these marks and tones will give you different focal points and direct your eye to the face, over and around the legs and neck, and so on. Even when you draw a standing, long-haired animal, the clustering of vertical lines can add stability.

4 **Wet fur coats** When sketching bears, dogs or other animals that enjoy a dip in the water, how do you draw that random mess of hair? First, make sure the sketch doesn't get out of control. Yes, the hair is weightless but it doesn't mean it's shapeless. Hair forms in clusters and you can rhythmically draw it with fluid shapes and curving lines. Give the illusion of water currents and lines flowing across the body.

5 **Light logic and fur** In translating the directed light that falls on your creature into a drawing, you may have to ignore texture and complexity in order to contrast lights and darks. That means "burning out" the hair textures and simplifying the fur into a large, almost empty value. Then, place most of the textural details into the shadowed areas. When you layer that information, you get an interaction between light and texture.

Capturing dynamic markings

Due to the sheer volume of differing markings on animals, you will have to be inventive and fluid in your approach to drawing them. There is a lot of suggestion and interpretation in the shorthand methods you can use to define the distinct characteristics of camouflage and coloration.

Tips to get you started

1 **Patterns and visual flow** Many animals have a pattern of markings on them, making it easier to explain gesture and form. There is a weird combination of organization and randomness to any pattern of surface markings. The idea is to see both working in concert. Find the bigger forms first and block them in with line or tone. Edit out the distractions of little erratic spots or stripes. Find a couple of stripes or marks that reinforce the original form.

2 **Tiger and zebra stripes** Drawing the stripes on these animals is either a curse or a blessing. On one hand, you have an obvious rhythmic pattern; on the other, stripes can become as visually boring as looking at a picket fence — uniform and flat. Use the spirit of what you see. Stripes break and fork at the shoulders, hip and knees, and wrap around the legs.

3 **Giraffe shapes** To expect anyone to draw a complex arrangement of spots on a giraffe in five minutes would be asking the impossible. Simple shape design is the key. Here you have interlocking shapes like paving stones with

white borders. Remember that shapes curve over the moving form. With limited time, start at the head and neck, or that big area at the hip, for the shape rhythm, and fill in at your leisure.

4 **Random patterns** Many small pets and animals have random patterns and colors. These elements can be found in creatures with long and short hair. You can use lines of various lengths and widths to define how surface markings and forms work in tandem. A little, puffy dog can have dark markings but lots of hair, so the dark tones will fan out and suggest a soft surface. On the other hand, light spots on short hair can be suggested with short dashes of overlapping line for a condensed, dark look.

5 **Birds, feathers, and markings** With complex feather patterns and the colors involved, try and layer your color. Suggest a few solid shapes and patterns on the wings or tail. That will indicate how it fits the wing and tail area volumetrically rather than becoming a flat pattern. Find your color shapes. Fill them in and then quickly block in the feather shapes.

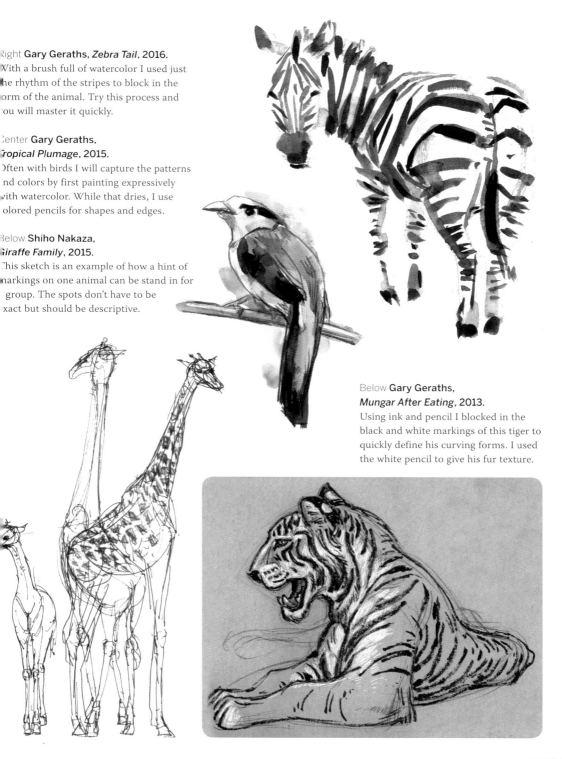

Right **Gary Geraths**, *Zebra Tail*, 2016.
With a brush full of watercolor I used just the rhythm of the stripes to block in the form of the animal. Try this process and you will master it quickly.

Center **Gary Geraths**,
Tropical Plumage, 2015.
Often with birds I will capture the patterns and colors by first painting expressively with watercolor. While that dries, I use colored pencils for shapes and edges.

Below **Shiho Nakaza**,
Giraffe Family, 2015.
This sketch is an example of how a hint of markings on one animal can be stand in for a group. The spots don't have to be exact but should be descriptive.

Below **Gary Geraths**,
Mungar After Eating, 2013.
Using ink and pencil I blocked in the black and white markings of this tiger to quickly define his curving forms. I used the white pencil to give his fur texture.

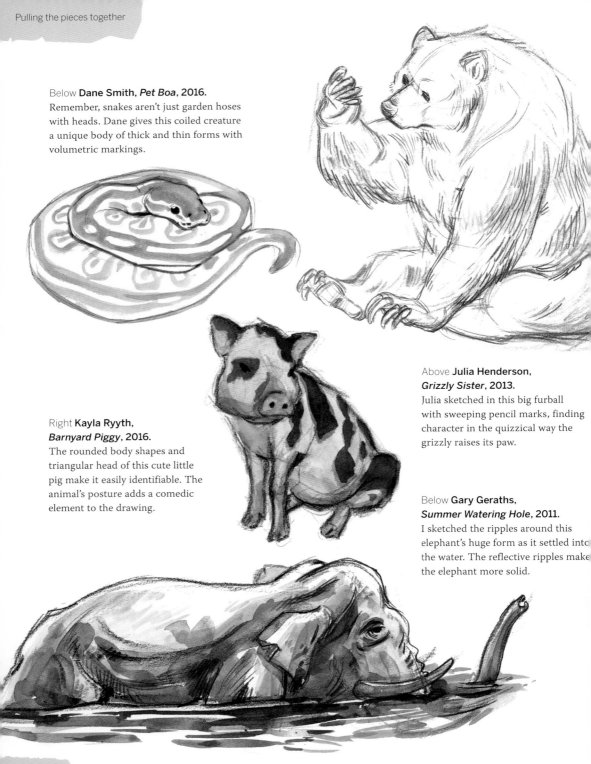

Below **Dane Smith**, *Pet Boa*, 2016.
Remember, snakes aren't just garden hoses with heads. Dane gives this coiled creature a unique body of thick and thin forms with volumetric markings.

Right **Kayla Ryyth**,
Barnyard Piggy, 2016.
The rounded body shapes and triangular head of this cute little pig make it easily identifiable. The animal's posture adds a comedic element to the drawing.

Above **Julia Henderson**,
Grizzly Sister, 2013.
Julia sketched in this big furball with sweeping pencil marks, finding character in the quizzical way the grizzly raises its paw.

Below **Gary Geraths**,
Summer Watering Hole, 2011.
I sketched the ripples around this elephant's huge form as it settled into the water. The reflective ripples make the elephant more solid.

Drawing unique animals

Many animals don't fit the usual, recognizable appearances of larger, more familiar creatures. They are unique in their proportions, silhouettes, facial features or even patterns of movement. These animals are entertaining to draw, with bodies and faces unique to their character.

Tips to get you started

Big stuff Rhinos, hippos and elephants can be drawn with big strokes. Big torsos, boxy heads and angular facial features need focus to make sure the proportions are correct. Sketch these creatures in the round so the features connect, then accent elements like wrinkly eyes, thick ears, horns and tusks. Prominent noses and mouths are fun to sketch — long trunks, huge box forms for hippos, and triangular-shaped upper lips hanging over a rhino's boxy mouth.

Long necks Sketching camels, llamas, giraffes and other creatures with elongated necks and ungainly stances requires long, curving marks along the line of action from the head to the tip of the tail. Pay special attention to the leg lines coming off the shoulders and hips, and anchor the feet to the ground plane.

Bears, large and small With all of that fur, the structure of bears can sometimes become lost. Draw the body and head with round and square forms, with the legs melting into the torso. A big, meaty hump rises over the shoulders; draw the head emerging from it. Grizzly, pandas and koalas have rounded forms for the head. Black bears have square-shaped craniums, and polar bear heads have a triangular form.

4 **Small creatures** Some small animals can fit into the palm of your hand. Most can be drawn delicately, with tiny bodies and triangular heads. They are largely quick-footed, with masses of soft fur. Take your pencil on its side and use gradient tones to quickly depict the forms, then move on to those triangular heads and expressive eyes. These animals include foxes, hedgehogs, raccoons and rodents. They are simply constructed creatures — great subjects for introducing children to drawing.

5 **Scaly pets** These obviously don't qualify as mammals, but all the same are kept as pets and also reside in many zoos. This group includes alligators, turtles, lizards and snakes. Their common structure is made up of simple shapes, angular legs and wedge-shaped heads. When drawing turtles, block in shells with shapes of domes, dinner plates and pyramids, with geometric patterns on top. The textures are rough, so active lines should be used. Lizards and snakes share long, tubular, twisting bodies with arrow-shaped heads. Lizards have angular legs with skinny claws. Drawing these creatures takes a combined technique of smooth line and choppy, angular marks.

Capturing human qualities in primates

Apes and primates are personable and animated. In many ways, they look and act like humans, with similar facial structures, expressions and anatomy, which perhaps makes our drawing process easier. One of the joys of drawing these creatures is observing and sketching their near-human social interactions.

Tips to get you started

1 **Gorillas** The facial features of gorillas are very close in proportion to humans but with some differences. Sketch in the brows with a heavier ridge. This gives the big ape a serious, studious expression. Use very elastic, curving lines to curl the mouth and thick lips up for different expressions. Encase all of this in a massive, boxy head. Give your subject weight and dignity.

2 **Chimpanzees** In comparison to brooding gorillas, chimps are quick, athletic and spend a great deal of time engaging in social play. To tackle the head, start with two overlapping ovals and place the eyes about in the middle. Explore the brows, wrinkles and the animation in the eyes as the chimp plays. Push and pull the lips to expose the teeth and corners of the mouth. Note that as chimps age, they grow more wrinkles and lose more hair.

3 **Orangutans** For these gentle creatures, use soft, flowing lines that combine the facial features and hair in an impressional image. The brows and eyes are close to the surface and need delicate marks to indicate character.

For the body and gestures, draw the arms long and powerful for climbing, with long hair. Use fluid lines to hint at the lack of broad angles.

4 **Mandrills and baboons** These are the tough, little guys of the ape family, so draw them with authority and assuredness. They walk and handle themselves like chimps, but draw them with swagger and aggressiveness. What is markedly different is their faces: long noses, small eyes and big, dagger-like teeth. Their heads are shaped like a "T" and surrounded with a mane of hair.

5 **Playful primates** This category encompasses many of the smaller primates like lemurs, capuchins, spider monkeys, gibbons and at least a dozen more. These are the climbers and swingers who spend a lot of time chattering and grooming. Generally, draw them with round faces, circular eyes and lots of crazy hairdos sticking out of the head in organic shapes. Learn to sketch them with curving, athletic strokes. They don't stay still for long, so get that animated motion down nice and confidently.

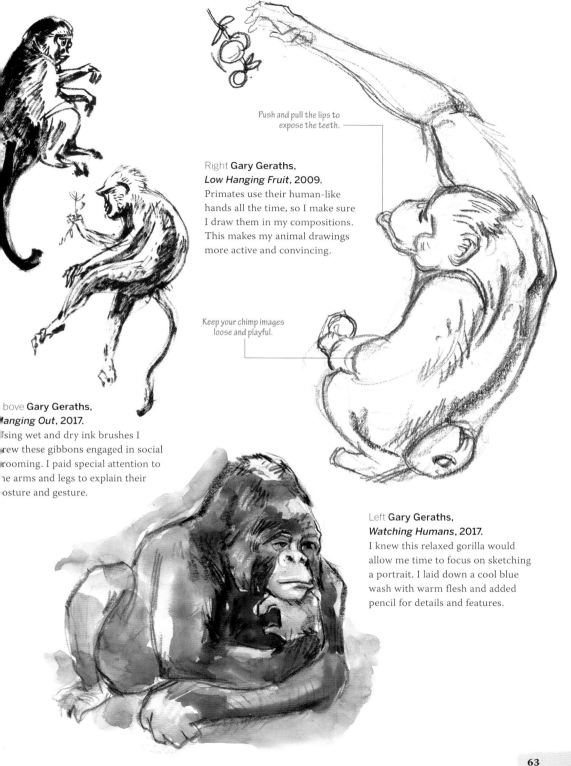

Push and pull the lips to expose the teeth.

Right **Gary Geraths,**
Low Hanging Fruit, 2009.
Primates use their human-like
hands all the time, so I make sure
I draw them in my compositions.
This makes my animal drawings
more active and convincing.

Keep your chimp images
loose and playful.

bove **Gary Geraths,**
anging Out, 2017.
Jsing wet and dry ink brushes I
rew these gibbons engaged in social
rooming. I paid special attention to
e arms and legs to explain their
osture and gesture.

Left **Gary Geraths,**
Watching Humans, 2017.
I knew this relaxed gorilla would
allow me time to focus on sketching
a portrait. I laid down a cool blue
wash with warm flesh and added
pencil for details and features.

Knowing the general shape
and location of features is
the vital first step.

Sketch in a triangular shape
which points to the beak.

Attach the lower
beak to the throat.

Right Gary Geraths,
***Structured Head*, 2017.**
I used a basic ball or wedge to
block out a bird head. To keep it
in order, I placed axis lines for the
eyes and the triangular beak.

Right Gary Geraths,
***Rooster Head*, 2017.**
I take full advantage of all the
facial ornaments and textures to
give my drawings character and
impact. The color markings draw
attention to the features.

Below Shelby Peterson,
***Intense Owl*, 2015.**
Using watercolor, Shelby
confidently painted the flowing
shapes and spotty textures on
her feathered subject. The use
of value and line brings focus
to that great expression.

Left Gary Geraths,
***Blue Crown*, 2016.**
When I sketch exotic birds
I love including their "hats" and
"hairdos" to make the portraits
unique, frame the bird's features
and add personality.

Expressive bird portraits

Though birds' faces are more uniform and the features aren't as flexible as those of mammals, they still are great subjects for portraiture, with plenty of life and character. Focus on the myriad of colors and feather types, allowing you to fill your composition with spectacular color combinations and shapes.

Tips to get you started

Building the head Birds move quickly, so knowing the general shape, forms and location of the features is a vital first step toward getting the portrait right. You can block in a generally boxy, round or triangular form depending on what its function is. Sketch in a triangular shape to create an arrow that points to the beak. Draw in the eyes at the side of the head and make sure you attach the lower beak to the throat.

Feather ornaments As part of your design, add the feather shapes that surround the head and/or neck. This will introduce variety to the silhouette of the portrait — useful when sketching peacocks, cockatiels or many other domestic and tropical birds. It's like drawing an interesting hairstyle or hat on your subject, and accentuates the expressive part of the bird's personality. This works in concert with the feathers that surround the head to create a textural necklace that frames the face.

Birds' eyes The eye holds the brightness and life of the bird portrait. When you draw an owl's eyes, they are large, round and have horns and fins attached as ornaments. Raptors have hunter eyes, with prominent brows and serious focus. Ducks should be drawn with their eyes located on the sides of the head. Sketch them in along with the bill to get the proportion right. It's an organic process, as you quickly sketch your subject with soft and hard line and tone.

4 **Lots of beaks** There are hundreds of different variations of bird beaks and bills. The best solution in drawing them is to identify the basic shape of the beak and its attachment to the head. You can really punch up the character of your subject by using sharp little lines for a sparrow's beak, or long, curving, gestural lines for a pelican's or toucan's beak. Study the bird when it opens its mouth, because that's when it's animated and the unique character of its personality emerges.

5 **Coloration and decoration** A lot of the impact of your expressive portrait will come from the coloration and patterns that cover your subject. Since you only have five minutes to get your sketch down, it's important to simplify the shape and fill it quickly with color. That said, rainbows of color markings shouldn't detract from the character of the bird. Draw a simplified pattern of feathers over the top of the color. You can let the colors do the job of making the drawing solid.

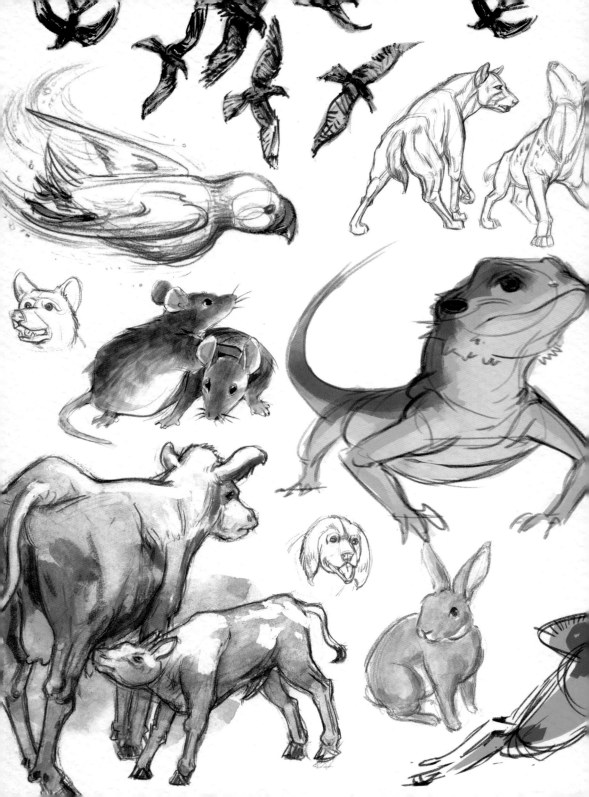

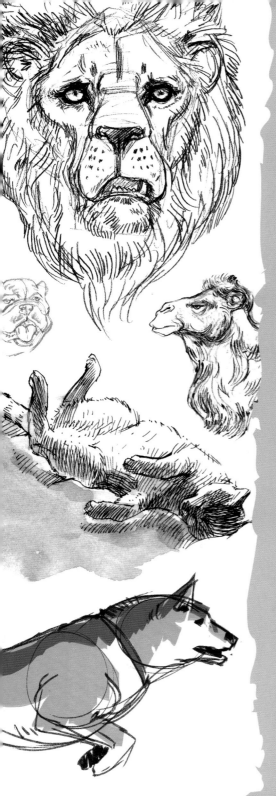

Fleshing out your sketch

Now that you have the basic structure, methods and head designs figured out, what can you add to your sketches to make them more complete? It's time to put some action in your drawings using dynamic muscle forms, action analysis, light and dark patterns, and even the effects of age. All of this will contribute to capturing the essence of an animal — in other words, its spirit. Your observational skills will be getting keener, your usage of materials more confident and you'll be charging forward in your sketching practice. To make a more solid image, we will look at how to add shadow and light logic, as well as how to make drawings that have implied movement with action poses and dynamic anatomy.

Left All of these drawings imply life and personality in the creatures' bodies, faces and poses. Putting dynamic action into your artwork can really make it unique.

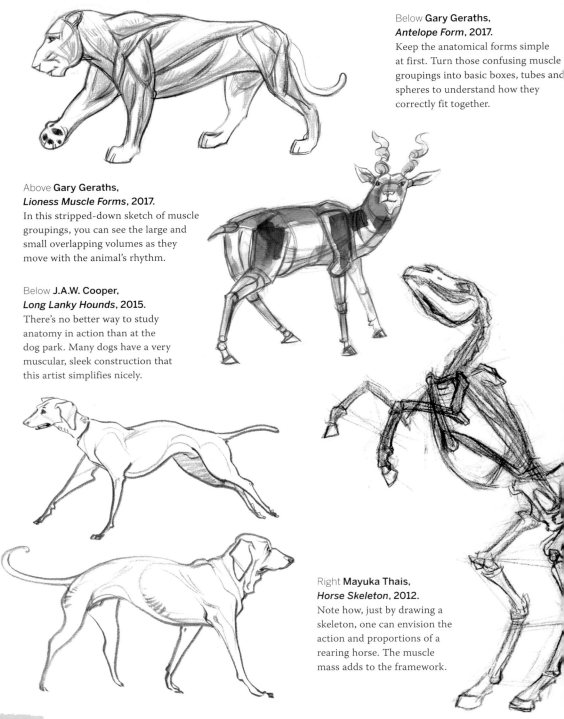

Below **Gary Geraths,**
Antelope Form, 2017.
Keep the anatomical forms simple
at first. Turn those confusing muscle
groupings into basic boxes, tubes and
spheres to understand how they
correctly fit together.

Above **Gary Geraths,**
Lioness Muscle Forms, 2017.
In this stripped-down sketch of muscle
groupings, you can see the large and
small overlapping volumes as they
move with the animal's rhythm.

Below **J.A.W. Cooper,**
Long Lanky Hounds, 2015.
There's no better way to study
anatomy in action than at the
dog park. Many dogs have a very
muscular, sleek construction that
this artist simplifies nicely.

Right **Mayuka Thais,**
Horse Skeleton, 2012.
Note how, just by drawing a
skeleton, one can envision the
action and proportions of a
rearing horse. The muscle
mass adds to the framework.

Dynamic anatomy

Muscular design and placement are shared in the vast majority
of animals you will be drawing. Muscle forms give your artwork a sense
of action, solidity and mass. That's true whether it's a short gestural
sketch of an athletic cheetah or a ponderous Indian rhino.

Tips to get you started

1 **Bone framework** In previous topics, we have looked at the effect the skeletal structure has in supporting how animals engage in dynamic movement. Don't throw that knowledge out just because you are adding form to your work. Instead, think of it as a new layer of technique. That simplified skeletal scaffolding makes for a solid location to apply the muscle masses and make your drawings more lifelike.

2 **Simple muscles** When you are sketching anatomy quickly, it's best to organize it into useful information. Take on the big chunks of the legs/arms, torso, neck and head first. These are overlapping forms, as discussed before, but now you are drawing links (thin, stretching lines) between the angular bone and rounded, curving, soft tone that is the muscle.

3 **Working muscles** With just five minutes to accomplish your goal, working fast and assuredly is key. Work up the animal's muscle forms as if you are watching a rubber band stretch and contract — that's what the animal's muscles do. The drawing line does the same — thin to thick and back again. In a creature there will be grooves and ridges appearing on the forms where the muscles come together or

show the volumes. Those are the best evidence of the animal's body in action. Look for these repeating landmarks as the animal moves to keep all the pieces in proportion.

4 **Surface anatomy** As the creature you are drawing is moving, build on those simple forms, such as the wedges, balls and organic boxes you are already using. Study and note the surface shadows and highlights that appear where muscle forms attach to the skeletal structure. Then, quickly sketch in the interaction between the angular and soft forms with sharp and curved lines. The contrasting array of marks will give your artwork a fine, expressional quality.

5 **Little creatures** This topic covers a wide range of barnyard animals, cats, dogs and pets. The sizes, actions and diversity of proportions are amazingly broad. So, when you draw, apply the muscles to the animal's character. Long and lean muscles on ferrets, raccoons and various kinds of dogs show rhythmic overlapping lines as you sketch. Domestic farm animals such as sheep and goats show a combination of lean and rounded forms.

Muscle power

Muscles and their mass express the essence of movement,
volume and weight. If you understand how they work, where the muscles
attach and how to create simplified volumes as the animal moves, you
will draw with a clear head and a creative vision.

Tips to get you started

1 **Know your subject** Remember, every animal you sketch has body and muscle forms built for its own unique environment and function. That means there are stresses and strains put on its body that sculpt its appearance and personality. Push your drawing with marks that surround and accent the corners of the mass or where the light and values change.

2 **Push and pull** You are now making decisive drawings charting how all these masses work in concert. There should be a connective line of action reaching throughout the drawing to pull them together. Draw what animators call "squash and stretch" — bunched up volumes and explosive streaks of lines and thin tone showing the animal reaching out, pulling and twisting portions of its body. This will make your drawing of form richer and more descriptive.

3 **Concave and convex** A big objective in sketching active animals, no matter the size or textural covering, is to give a liveliness and solidity to your images. Pushing the lines and tones concave (curved inward) and convex (outward) gives your animals a sense of added volume or stretching, and of pulling the volume taut. Look for the answers in the animal's anatomy because the muscles are fuller at the torso and thinner at the limbs.

4 **Experimental marks** You are trying to figure out how all these ingredients are baked into a successful "art cake." The best process is to try out various combinations of lines, tones and materials as you sketch. Block out the exterior lightly but build inside the forms, strengthening their shadow patterns and interior planes. Then push the outside contour lines and graphic shapes. Getting those dynamic muscle volumes to work with the outside line will really lend an impact to your work.

5 **Edges and corners** The best way you can show a solid appearance is by changing up your line character on the edge and corners of your muscle masses. Where the contours and corners of the volumes are softer, give a soft curving tone to the area where light meets shadow. If the area shows a taut or angular look, push a harder, sharper edge and line. You are pushing and pulling your drawing methods more than ever. Enjoy the ride.

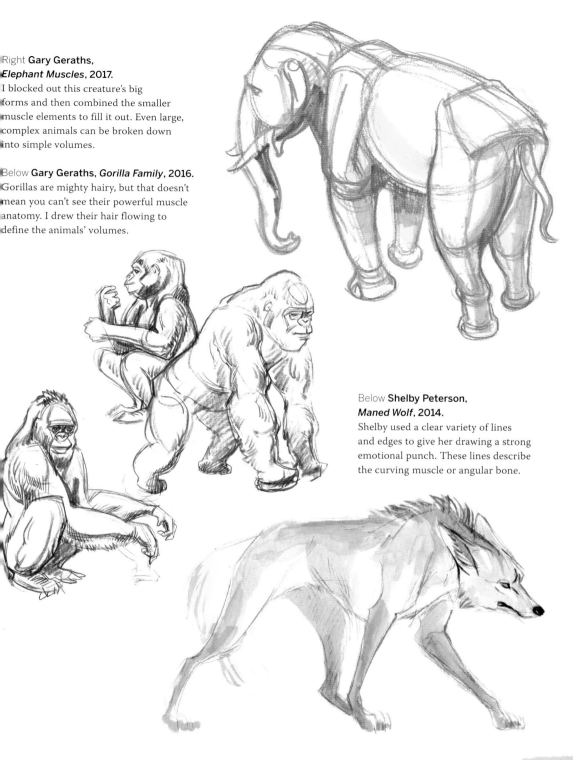

Right **Gary Geraths,**
Elephant Muscles, 2017.
I blocked out this creature's big
forms and then combined the smaller
muscle elements to fill it out. Even large,
complex animals can be broken down
into simple volumes.

Below **Gary Geraths,** *Gorilla Family*, 2016.
Gorillas are mighty hairy, but that doesn't
mean you can't see their powerful muscle
anatomy. I drew their hair flowing to
define the animals' volumes.

Below **Shelby Peterson,**
Maned Wolf, 2014.
Shelby used a clear variety of lines
and edges to give her drawing a strong
emotional punch. These lines describe
the curving muscle or angular bone.

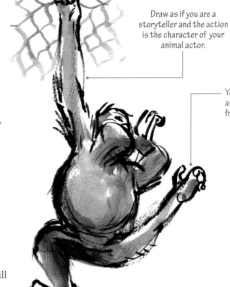

Draw as if you are a storyteller and the action is the character of your animal actor.

You are sketching implied movement so as not to make your sketch look like a frozen moment.

Right **Virginia Hein,**
Swinging Orangutan, 2007.
This drawing demonstrates how you can push an animal's limbs around and still have a sense of balance. To anchor the action, Virginia shows the ape hanging off the netting.

Below **Gary Geraths,**
Billy Walking Away, 2013.
Big doesn't mean stiff and lumbering. Elephants' hips and shoulders act like pistons, twisting and moving up and down in a rhythmic series of movements.

Below **Gary Geraths,**
Waystation Hyenas, 2015.
When startled, many animals will take a defensive posture and move into a triangular stance. These hyenas look ready to jump into attack mode.

Triangular stance typical of defensive animal

Left **Yumi Yamazaki,**
Swimming Puffin, 2016.
Yumi uses several smart drawing devices to express underwater action. The bird's sleek bullet shape and the curving sweep of bubbles show swift motion.

Action poses

When sketching action, you are also filling the image with mood and suggestions of character. The scene could be as action-packed as two big cats fighting or as calm as a domestic cat lounging in the sun. Your reaction to the action and interpretation of what you see will make for an insightful drawing.

Tips to get you started

1 **Seizing the moment** When sketching truly active subjects, such as running and jumping horses, playful dogs or monkeys swinging from branch to branch, you are jotting down rough sketches and lines of note. It's best to start with a subject that repeats its actions, such as a horse completing a jumping course. That way, you can draw the whole body in action in swift, overlapping lines, then sketch in the smaller details like hooves, feet, hands or wings. These are focal points for the eye to grasp important pieces of explanatory information.

2 **Pivot points** Much of the action you draw can be simplified by attaching the bigger swiveling forms to pivot points at the hips, shoulders, the top of the neck, bony knees, ankles and wrists. Think of the large and small forms swinging like a pendulum; as you draw them, it adds to the rhythm and flowing line of your drawing method.

3 **Weight and shapes** In staging your action, the shape and locations of the animal's body and extremities must be clear. Ask yourself how many legs you see, and if the proportions look right even as the animal twists and turns and is foreshortened. Are the head and tail accenting the lower body movement? Remember, the body parts are triangular and frequently point in the direction of the action, whether it's in the legs, arms or even the head.

4 **Follow through** As you observe your subject going through a thousand actions, it's important not to sketch as if this is a frozen moment. A drawing of gesture is made up of continuous action. You are sketching "implied movement." Watch for key images of action, such as horse hooves striking the ground and taking the weight of a jump, dogs rolling on the ground with limbs pointed all over the place, or orangutans slowly climbing a rope. Draw as if you are a storyteller and the action is the character of your animal actor.

5 **Checks and balances** The great thing about working with a diverse range of body shapes and sizes is the amount of fun you can have animating them. An elephant's weight can jiggle back and forth. Thin antelope can be drawn leaping into the air or standing on their twig-thin legs. Even the furry, grey, cotton ball chinchilla has a little angular face and hands.

Capture jumps and landings

One of the most exciting pieces of action you can capture is animals jumping and landing in a fluid motion. To achieve this, aim for a looser approach with gestural drawing. It may appear chaotic when you start, but action can be comprehended and sketched in an expressive series of images.

Tips to get you started

1 Fast and furious Leaps and landings happen at breakneck speed. When you sketch these actions, follow the line of action through the body to the legs. Let your pencil flow around the torso and then spring out as the limbs reach out to touch the ground. Try not to get confused and freeze up; instead furiously scan the action happening in front of you. Analyze it and scribble it down in a fast but organized way.

2 Explosive take off Think of an animal's process of starting a leap as akin to winding a main spring of a clock. The backbone and legs are coiled up into a tight mass. Draw that action with a combination of angular and curving lines, with the back legs firmly on the ground. Then, using some sharp, explosive lines, sketch the back legs pushing the figure forward and into the air. The lines you draw should move through the entire body to the hips and back limbs.

3 Bodies in motion When an animal comes up against an obstacle, it gathers up its energy, tenses up the back legs and then jumps. The front legs get pulled up as close to the torso as

they can get. Use a primary curve in your sketch that mimics the height and angle of the jump so it looks natural. It's important to communicate a weightlessness but also a strength and flow in your drawing.

4 Sticking the landing All of that weight has to wind up somewhere. Your job as an artist is to translate that landing (and its aftermath) into an image made up of line and tone. This is about confidently sketching where hoof, paw or foot comes into contact with the ground plane. Make sure the front part of the animal has a good center of balance over the landing spot. Most of the time both feet don't hit the ground at the same time, so show one foot landing on the surface to take the animal's weight.

5 Touch down At the end of the jump, after the animal's front legs have landed on the platform, the rest of the body's mass follows the same flowing pathway. That means the animal will coil up its back legs, anticipating a quick follow through for the back legs moving forward to complete the landing.

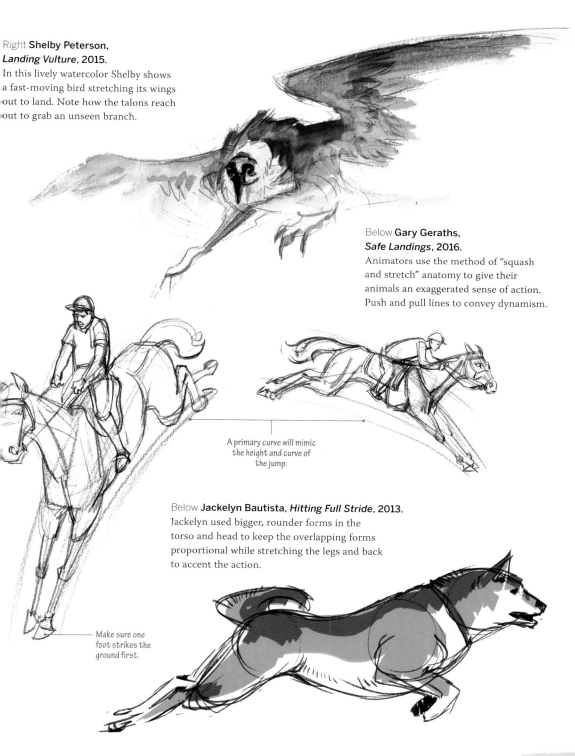

Right **Shelby Peterson,**
Landing Vulture, **2015.**
In this lively watercolor Shelby shows
a fast-moving bird stretching its wings
out to land. Note how the talons reach
out to grab an unseen branch.

Below **Gary Geraths,**
Safe Landings, **2016.**
Animators use the method of "squash
and stretch" anatomy to give their
animals an exaggerated sense of action.
Push and pull lines to convey dynamism.

A primary curve will mimic
the height and curve of
the jump.

Below **Jackelyn Bautista,** *Hitting Full Stride*, **2013.**
Jackelyn used bigger, rounder forms in the
torso and head to keep the overlapping forms
proportional while stretching the legs and back
to accent the action.

Make sure one
foot strikes the
ground first.

Below **Gary Geraths,**
Lioness Nala, **2013.**
Staring into the face of this big
lioness makes you realize the
importance of drawing eyes with
focus and a sense of soulfulness.
They must be placed correctly
to be believable.

Left **Dane Smith,**
Chinchilla Toshi, **2017.**
Some animal faces are all
roundness and fur with few
structural landmarks. Block
in the feature locations and
check sizes before committing
to a finished portrait.

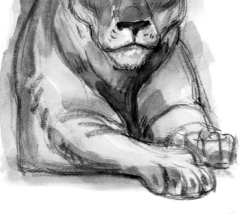

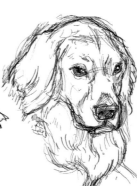

Right **Jackelyn Bautista,**
Bearded Dragon, **2017.**
Even when drawing lizards,
sometimes attitude is
everything. This
viewpoint and the
defiant stance force
the viewer to look
up and focus on
the creature's front
and face.

Above **Gary Geraths,**
Sparky and Kekko, **2013.**
No better way to spend the
afternoon than drawing my
dogs. The sketchy lines
combine facial proportions
and fur textures to capture
individual personalities.

Personality portraits

In previous topics we looked at how to break down the structure
of animals' heads and features, giving a simple head construction to adapt
for quick sketching. Now we will start to sculpt the face forms
on the head to unveil a greater sense of individuality.

Tips to get you started

1 **Unique silhouettes** Every animal type has its own recognizable head proportions that you can fall back on to identify and sketch. Here, the idea is to add and subtract from the head's basic shapes to create a unique animal portrait as individual as your own. Get rid of the portrait details and sketch in the contrasts and differences. Do the cheek fur shapes become large and soft in contrast to a pointy, triangular nose? Are the subject's ears large and rounded compared to a tiny, square nose?

2 **Hard and soft forms** When you are quickly sketching, your pencil technique is telling a story about the surface texture of the animal's face. To bring out the personality of a tough-hided rhino, you need hard, angular lines. For a fluffy-cheeked dog, the forms should curve out and the pencil be turned on its side to lay down soft, arching tones.

3 **Lots of eyes** Like humans, there are lots of variations of size, shapes and anatomy of eyes in the same species. Depending on the brows, bags and lids, the shapes vary, so view the entire area around the eyes and eye sockets as part of the animal's character and face. You can draw thin eye slits surrounded by fur or big,

moon eyes surrounded by heavy brows and wrinkles. The variations are limitless. Sketch in with a light line, simplify it, and then commit to anchoring the eyes to the face.

4 **Puzzle pieces** No matter which creature's face you are drawing, it's important to get all those facial features to work in tandem. Big eyes, little beaks, noses, wide mouths and big ears are to be taken note of and sketched to connect everything into a solid portrait. Then, add textures and surfaces, scales, hides, markings and so on. Stay calm, organize your thoughts, look and then commit to piecing together the subject's portrait successfully.

5 **Sharp horns and tusks** Every animal with antlers, tusks or teeth has another element to make for a better portrait. All these items have their own shape and growth pattern that can be used to frame the face or add to the unique personality and shape. Aim for long forms and jagged edges with tusks and exposed teeth. These sometimes weirdly-shaped items can give your drawing impact.

Capturing emotions

Animals display a wide array of facial movements and expressions. Like humans, there is a system of muscles and bone structures that work together to give you an indication of the creature's state of mind — its emotional state. Even birds, with their fairly stationary head structures, can have expressions.

Tips to get you started

1 Get it right It's very important to get the proportions of your subject correct, because if your animal isn't recognizable, all the facial feature gymnastics won't count for much. Organize the forms and planes of the face first, then start to twist and turn the features to give visual punch. When you correctly couple the expression with the animal's body language, it will give your sketch more meaning and impact.

2 The eyes are the prize Like humans, the emotion in an animal's eyes is a focal point to carefully accent. Most animals have similar bone and muscle set-ups to people, so they have the same range of expressions. Eyebrows rise, eyes get bigger with surprise, brows pinch down toward the nose and the eyes turn into angry triangular slits, with heavy folds and menacing shadows you can add to accent the intent. Use thick marks to anchor the eyes into the socket brows and curving lines to draw around the edges for tear ducts and wrinkles.

3 Angry noses A great, quick method of showing emotion is to give the illusion of the muscles on top of the nose furrowing back into a series of thin half-pipes. This works in concert with the eyes. Seen mostly when an animal is angry,

there are a bunch of variations that can also include calm expressions, such as a giraffe slowly chewing leaves, or mice and raccoons nibbling on bits of food. Once again, much of the expression will come from your drawing technique and character of line.

4 Big mouths The huge variety of animal mouths gives you another way to show character in your sketch. Depending on the animal's action, you can sketch in the shape of the mouth using for example, triangles for dogs or horseshoe shapes for cattle. Most of the time there will be lips of different widths lining the mouth — these are elastic and offer great potential for accenting the teeth to indicate eating, anger, warnings or even the hint of a smile.

5 Body language Most of the time, you will be drawing the whole animal in motion and not just the head. This means that you must make the creature's body gestures match the facial expression. Line and tone should unify the drawing's emotion into a solid statement. Pull the lines through the head and body and use a series of marks and body positions to describe rest, anger or playfulness.

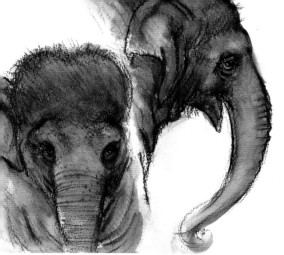

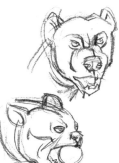

Right **Gary Geraths,**
Dog Park Portraits, **2016.**
I drew these fast little pooch portraits in a deliberately comical style. I used almost human-like facial expressions to get quick and clear ideas across.

Above **Virginia Hein,** *Gentle Lady*, **2001.**
Virginia drew these subtle yet engaging portraits with watercolor and pastel. Note the combination of the soft face texture and the glint of light in the brown eyes.

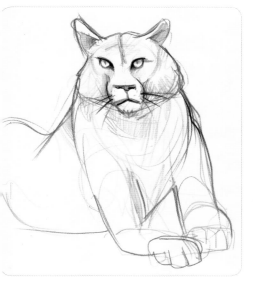

Below **Gary Geraths,**
Angry Gull, **2008.**
I drew this bird while it was stomping around squawking for food scraps. I drew its pointed beak open and beady little eyes to emphasize the expression.

Above **Nikolai Drjuchin,** *Icy Stare*, **2015.**
When trying to focus the viewer's eye on a particular feature or expression, use darker lines and values. Even simplified features can show emotion when balanced correctly.

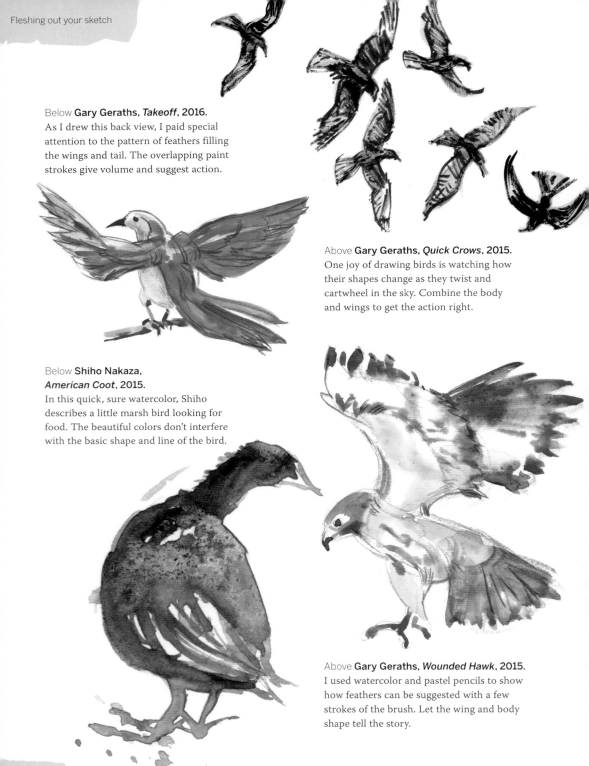

Below Gary Geraths, *Takeoff*, 2016.
As I drew this back view, I paid special attention to the pattern of feathers filling the wings and tail. The overlapping paint strokes give volume and suggest action.

Above **Gary Geraths, *Quick Crows*, 2015.**
One joy of drawing birds is watching how their shapes change as they twist and cartwheel in the sky. Combine the body and wings to get the action right.

Below Shiho Nakaza, *American Coot*, 2015.
In this quick, sure watercolor, Shiho describes a little marsh bird looking for food. The beautiful colors don't interfere with the basic shape and line of the bird.

Above **Gary Geraths, *Wounded Hawk*, 2015.**
I used watercolor and pastel pencils to show how feathers can be suggested with a few strokes of the brush. Let the wing and body shape tell the story.

Catching birds in flight

Birds are fascinating to watch and sketch. Whether they are gracefully gliding along air currents or diving at a furious speed to catch prey, there are dynamic designs to be found in birds' movements and appearances. You will need a quick mind and hand when you try to capture these creatures at different points of takeoff, flight or landing.

Tips to get you started

1 **Bird structure** There are thousands of different species of birds, encompassing a multitude of sizes, proportions and flying actions, but the basic structure could almost be seen as human. Birds' wings have arms and fingers (which on a bird would be primary feathers) that form triangular wing shapes and operate in a similar way to how humans would flap their arms like wings. Make sure you give your drawing a liveliness and organic swing-and-sway.

2 **Takeoff** One of the most fun aspects of sketching birds is their long-running takeoffs or explosive quick leaps off a perch to gain flight. This is when the size and shape of the wings are exposed and where you have to sketch in their proportions and match the body shape to wing. You will most likely be drawing a rather curving, zigzag form. As the bird starts catching the air to lift its body off the ground, define the shape quickly, because its position will change fast.

3 **Wing design** Basic points to focus on in drawing flying birds are the length, shape and use of their wings. Soaring and high-speed wings are long and slender to catch updrafts for long-distance flights, or to hover and then dive

on prey. These wings have a rectangular base that's attached to the body with triangular shapes stretching to the tips. Block them out and put them in action with slightly curving forms. This will give you a solid base on which to sketch the individual feathers with interesting serrated edges at the tip.

4 **Landings and folding wings** As a birds readies for a landing, body angle and motion come into play. The wing folds in and the shapes overlap. The bottom of the body and legs swing forward to touch the ground or grab branches. Draw these actions with a combination of curving and angular lines where the wings, talons and body come together.

5 **Tail feathers** To complete your sketch, use the tail feathers to enhance your image. The tail bends and twists to help direct the bird's flight, like a rudder on a ship. It's shaped like a fan — draw it with curves and attach it to the body, capturing its grace and the way it counterbalances the wings and head. Feathers also form serrated edges that make for an interesting accent and catches the viewer's eye.

Fast shadow patterns

Shadows give weight and visual substance to your artwork. To get them right, you must learn to quickly draw large strokes, value planes and patterns using various materials to give your sketches not only solidity, but also warmth and liveliness. This will require confidence in applying dynamic values and lines.

Tips to get you started

1 **Big picture** Before worrying about the complexity of jotting down the shadow patterns on animals, it's important to apply them to the basic shape of your subject. The shadow and light shapes that control the illusion of form on the animal vary from large to small. As you block out these shadow shapes and light shapes, they complete the whole shape of your animal's outline. If the majority of the shapes are dark, the animal is in shadow; if the values are dominated by light tones, it's in the sun.

2 **Puzzle pieces** As the light source and the animal change position, the shadow patterns, shapes and edges shift. This means that not only will the shadow shapes change, but also the edges of the shapes. Let the drawing materials twist and turn, using sharp-edged, pointed strokes or broad sweeps of tone and planes. This will give your drawing the solidity of sharp skeletal structure or softer, rounder volumes. Like a visual roller-coaster, the eye will move through your drawing at speed.

3 **Shape breaking** Lend a dynamic look to your sketches by creating a shape rhythm from small to large. The idea is to compare and contrast the shadow patterns — the puzzle

pieces — between light and dark patterns. You can break down the comparative shapes to include the head, legs and arms to complete the process.

4 **Stacked forms** One notion to grasp is that you can really add volume and gesture to your sketches by overlapping the shadow patterns you see. That means that instead of carefully matching the shadow edges, you take the big planes and overlap or "weld" the large forms together to create a rhythmic shadow pattern. Drawing or painting this way will cause the values to change from light to dark and suggest variations of light density, which will make for solid drawings.

5 **Surface textures** Buried in and accenting your sketches are the surface textures of fur, hide or feathers. Use your marks and strokes to replicate how the textures accent the shadow forms. Textures shouldn't overwhelm the design but move the eye through your sketch, showing the viewer how the textures make the animal's personality more individual and interesting. Try experimenting with many materials and methods to get the right solutions.

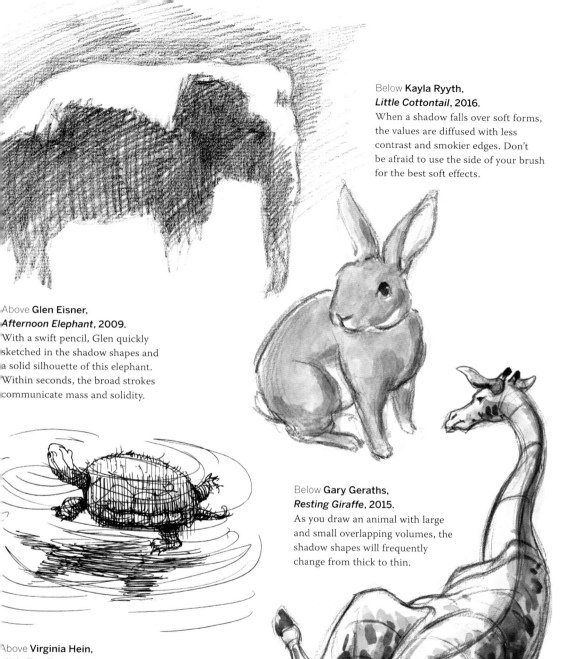

Below **Kayla Ryyth,**
Little Cottontail, **2016.**
When a shadow falls over soft forms,
the values are diffused with less
contrast and smokier edges. Don't
be afraid to use the side of your brush
for the best soft effects.

Above **Glen Eisner,**
Afternoon Elephant, **2009.**
With a swift pencil, Glen quickly
sketched in the shadow shapes and
a solid silhouette of this elephant.
Within seconds, the broad strokes
communicate mass and solidity.

Below **Gary Geraths,**
Resting Giraffe, **2015.**
As you draw an animal with large
and small overlapping volumes, the
shadow shapes will frequently
change from thick to thin.

Above **Virginia Hein,**
Little Zoo Turtle, **2001.**
This little ink sketch does three different
jobs at the same time. The vertical
hatching lays down volume; the ripples
show the water's surface, and the shadow
indicates the bottom of the pond.

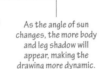

Below Virginia Hein,
Sleeping Tabby, **2003.**
With contrasting hatched line
and washy tones, Virginia draws
a subtle interplay between wet
and dry ink techniques. The late
afternoon light casts a soft shadow.

As the angle of sun
changes, the more body
and leg shadow will
appear, making the
drawing more dynamic.

Above **Gary Geraths,**
Shadows in the Park, **2017.**
Sketching in the afternoon, I drew long
shadows that reinforced the dogs' forms.
It's important to connect the vertical
figure with the horizontal ground.

Let your shadows follow
the rock forms.

Above **Gary Geraths,**
Lioness on the Rocks, **2017.**
I painted the surface shadow with a
jagged pattern of warm and cool colors.
This dark cast shadow gives the ground
various forms and texture.

Left **Glen Eisner,** *Iguana*, **2002.**
With some quick diagonal strokes,
Glen places the lizard on the uneven
ground plane. The pencil strokes make
the stomach scrape the gravel floor.

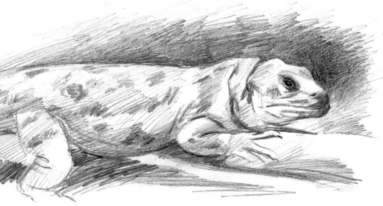

Anchoring ground shadows

It's time to connect your animal sketches to a ground plane. Use these techniques of value, color and terrain to give your drawings a stronger sense of place and space. Shadows tell a more complete story about your animal and the environment it exists in.

Tips to get you started

1 **Shape changing** It's important to connect the time of day and the size of the animal. If the sun is overhead, chances are the shadow shapes the animal casts will be bulky and there won't be much evidence of the limbs. Draw with consideration of the subject's length and width. As the sun's angle gets closer to the horizon, the animal's silhouette and legs will appear and help make the composition more exciting. Note that the sharp angle of the light will make limbs look thinner, so draw them that way. Thick shapes in a long shadow can ruin your image.

2 **Shadow sewing** Something to keep in mind as you stitch figure and ground together is how the animal's shadow shape changes depending on the terrain. Granted, if the shadow falls on level ground, the shape will be easily recognizable — a few quick pencil strokes will do the trick. But if the animal's shadow falls on rocky or jumbled terrain, the shadow shape will be fractured. Let your strokes follow the rocks, tree trunks and ground cover forms.

3 **Surface shadows** A good deal of your job in putting all this together is to communicate what the creature is standing or sitting on. This could be grass, rocks, mud and so forth. Use a wide variety of color and marks to define the terrain — sharp strokes for grass, big blocks of tone for dirt and rocks, smooth values for concrete and sand.

4 **Color shadows** Though this tip covers color, it all starts with value. It's important to find the correct value to draw your shadow, ensuring your animal has a solid connection to the ground. Most of the time you will be using a blue color to paint or draw a shadow shape onto the ground surface — cool shadows on warm-colored rock and dirt. Paint or draw the shadows as if they're a light blue veil draped over the ground, bushes or grass.

5 **Water shadows** Just because an animal goes wading into a water pool doesn't mean it won't cast a shadow on the surface. Water has a somewhat solid surface that will reflect an animal's image and have a shadow thrown across it. The shadow breaks up in ripples that surround the animal's form and reflect its shape and value onto the water's surface. It's important to make sure the ripple pattern doesn't break up too much and destroy the shadow shape, losing the creature's personality.

Animals interacting

Frequently, you will be sketching in places or at events where there will be groups of animals interacting — playing, sleeping, eating, tussling and fighting. This means that you will be drawing several creatures — perhaps even different kinds of animals — intermingling.

Tips to get you started

1 **Small, simple groups** To get a handle on sketching groups of animals, concentrate on a couple of creatures at a time. This will allow you to sketch them as one simple unit of gestural lines and tone. As you draw, you will see if you want to tangle them together, break them apart or overlap them moving in tandem. Think of them as a single force of nature.

2 **Everyday routines** Seek locations where animals group together. Zoos, dog parks, equestrian centers, even pet shops are great places to find ready clusters of animals to sketch. Pick simple actions, such as animals grazing, eating or sleeping together. Intermingle the lines and then, as you find the individual forms, accent the boundaries between them.

3 **Animals and humans** It's not just interactions between animals that can be the focus of your drawing, but animal-human interactions as well. Walking dogs, horseback riding — all sorts of activities can be used as a way to test and show off your drawing skills. Drawing people is not dissimilar to drawing animals; rely on simple shape and proportion to sketch the human form in motion. If you are sketching horses and riders, work them up together as one unit and then accent where the legs and arms differ from the torso of the horse. These situations don't have to be action-packed; they can be as simple as someone cradling a pet in their lap.

4 **Big groups** A great training exercise is to find a large group of herd animals and sketch them in extremely simple, overlapping shapes and forms. This can also means sketching several different animals simultaneously. Often, zoos and animal parks will put herd animals together — their shapes will overlap when they graze or drink together. Sketch these large, gestural groups and their surroundings, then focus on key subjects and make them recognizable.

5 **Flocks of birds** Don't forget that birds frequently get together in large numbers at farms, zoos, wild life refuges, or even at home on bird feeders and in nests. Watch the flexible shapes of the birds' wings, bodies and heads. The movements will be quick and direct and on the ground, the wings folded up into the body shape. In flight, the wings are your primary tool to show movement in a flock's interactions. Try painting flocks of birds quickly, blocking out groups of forms and then build out the similar characters of feathers, beaks and eyes.

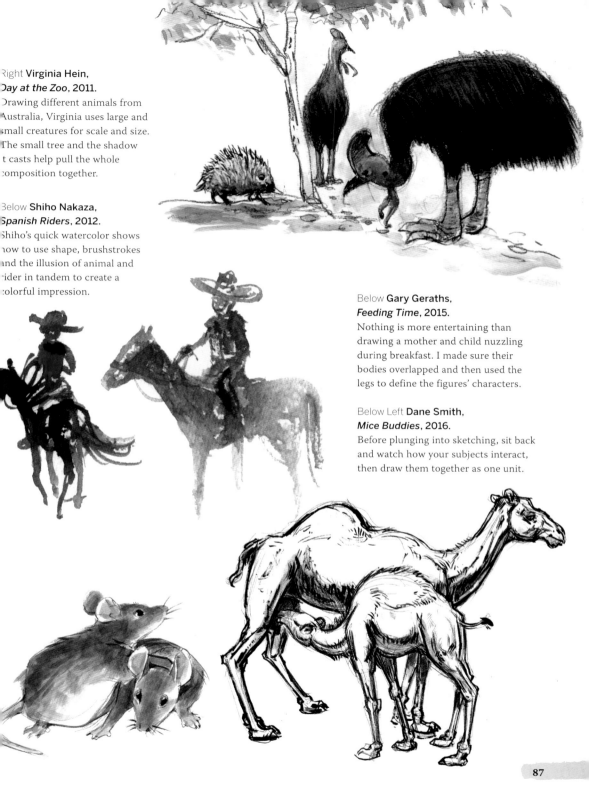

Right Virginia Hein,
Day at the Zoo, 2011.
Drawing different animals from Australia, Virginia uses large and small creatures for scale and size. The small tree and the shadow it casts help pull the whole composition together.

Below Shiho Nakaza,
Spanish Riders, 2012.
Shiho's quick watercolor shows how to use shape, brushstrokes and the illusion of animal and rider in tandem to create a colorful impression.

Below Gary Geraths,
Feeding Time, 2015.
Nothing is more entertaining than drawing a mother and child nuzzling during breakfast. I made sure their bodies overlapped and then used the legs to define the figures' characters.

Below Left Dane Smith,
Mice Buddies, 2016.
Before plunging into sketching, sit back and watch how your subjects interact, then draw them together as one unit.

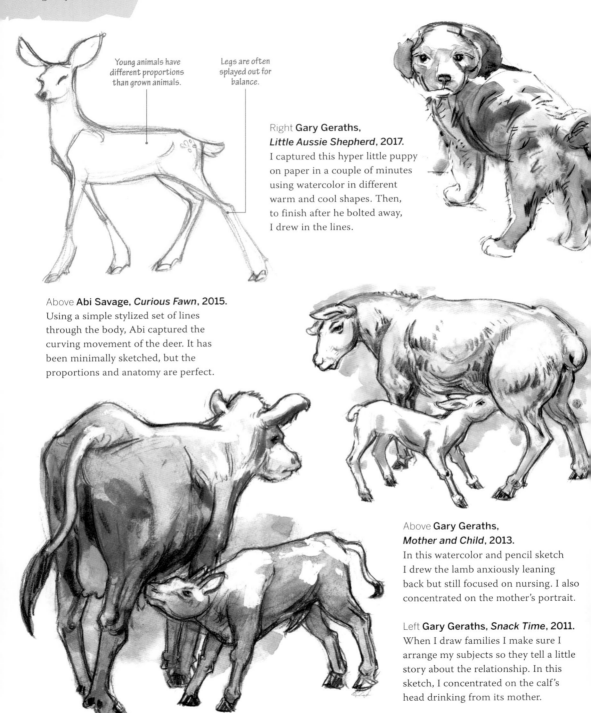

Young animals have different proportions than grown animals.

Legs are often splayed out for balance.

Right **Gary Geraths,**
Little Aussie Shepherd, 2017.
I captured this hyper little puppy on paper in a couple of minutes using watercolor in different warm and cool shapes. Then, to finish after he bolted away, I drew in the lines.

Above **Abi Savage,** *Curious Fawn*, 2015.
Using a simple stylized set of lines through the body, Abi captured the curving movement of the deer. It has been minimally sketched, but the proportions and anatomy are perfect.

Above **Gary Geraths,**
Mother and Child, 2013.
In this watercolor and pencil sketch I drew the lamb anxiously leaning back but still focused on nursing. I also concentrated on the mother's portrait.

Left **Gary Geraths,** *Snack Time*, 2011.
When I draw families I make sure I arrange my subjects so they tell a little story about the relationship. In this sketch, I concentrated on the calf's head drinking from its mother.

Drawing young animals

The wonderful thing about sketching young animals is capturing their vitality. You must be quick and resourceful to capture their youthful, playful, yet awkward movement on paper. With big, oversized eyes, cute expressions and boundless energy, they are fascinating subjects.

Tips to get you started

1 Angles and curves Due to the fact that they haven't fully developed, young animals have different proportions than grown animals. Since the muscles haven't matured and filled out, the skeletal system creates the framework for that youthful energy. On the other hand, many animals are little more than big balls of fur with faces and feet sticking out. Your drawing techniques will vary depending on your subject.

2 Baby faces Young animals grow into their features. Eyes are usually large and glistening with moisture, with big eyelids. Noses are cute and smallish, with round muzzles and expressive mouths. In previous topics, we have broken down the head structures of adult animals; use the same techniques but adjust the proportions and soften the edges when needed. Simplify the edges and structure — and don't forget the cuteness factor!

3 Line of youthful energy Try and invest your drawings with some of the pent-up enthusiasm and awkward energy these young animals have. Most of these creatures are still learning to walk, run and keep up with their moms and siblings, so they are ungainly. Watch and draw the actions of the legs; they go all over the place — sometimes splayed out to catch the animal's balance, occasionally knock-kneed, and, more often than not, tripping and falling over their own feet.

4 Balls of fur The younger animals you will be sketching will most likely be pets or perhaps barnyard animals. Most of these are covered with fur and therefore can be drawn with any media that can be put down with a soft, rounded edge. Capture the light and texture first and then worry about markings later. For small animals with spiky coverings and erratic, knotted hair, turn the pencil in different directions, using short, overlapping strokes to depict the texture.

5 Mother and kids One of the most touching things to draw is the interaction between animal family members. Young animals tend to stick around their mothers for food and protection. Draw them all as one unit. Find the forms; look for the character differences. A mother will most likely stay calm and stable, which may mean solid lines and vertical posture. The hungry kid may be very ungainly, with an awkward posture, so your marks may be more erratic and disconnected.

Capturing age

Maturity in animals brings a wider variety of character, personality and drawing approaches. Your line and tone can search over the forms and faces and highlight the wrinkles, folds and surface coverings. It will take an ability to edit and accent the materials that you lay down to capture the dignity and majesty of elderly animals.

Tips to get you started

1 **Old posture** Your first job in capturing the essence of your animal is to convey how it holds itself and the posture it strikes. As the aging process takes hold, the muscle forms change. This can go in two different directions. One is that some animals lose the muscle tone, and forms hang off the skinny, skeletal frame. Your lines should be elongated, with the form curves hanging off the bottom of the animal. In the opposite direction, many animals get rounder and heavier, so use curving lines and rounded edges to communicate the weight.

2 **Portraits of wisdom** With years behind them, the life of an animal can show in many ways. Wrinkles cover the head; skin sags; perhaps the animal has lost hair or is greyer. This exposes more erratic patches of skin, but when you draw them, it should still express a dignity and sense of pride. This is achieved through a greater degree of simplicity and design.

3 **Big faces** Large animals like elephants, cattle, hippos and rhinos have their own thick-skinned facial features that can be accented or even exaggerated to play up the age of the creatures. Two central features to focus on are the eyes

and ears. Lots of big animals have heads large enough to allow you to see a lot of detail. Ears might be chewed up, torn or cracked. The bags under the eyes get heavier with more wrinkles, which means deeper lines and tones.

4 **Pets at home** We live with our pets and watch them grow older, getting to know every hair and wrinkle on their face. The color of the fur changes; it loses its luster. There might be less of it. Perhaps the eyes lose some of their gleam. Study your pet's face for the best portrait that conveys the effects of age, but also the image of an old friend. Design the head to bring out the age, but accent who your subject really is.

5 **Ape and monkeys** Apes and primates age very similarly to humans. Therefore, you can use how we age for inspiration. Frequently, you'll notice that youthful faces that were once covered with hair have lost most of it over time. The brows become heavier, the ears longer and the wrinkles deeper. Once again, you have to watch how all these exaggerated proportions work in concert to create a series of unique portrait statements.

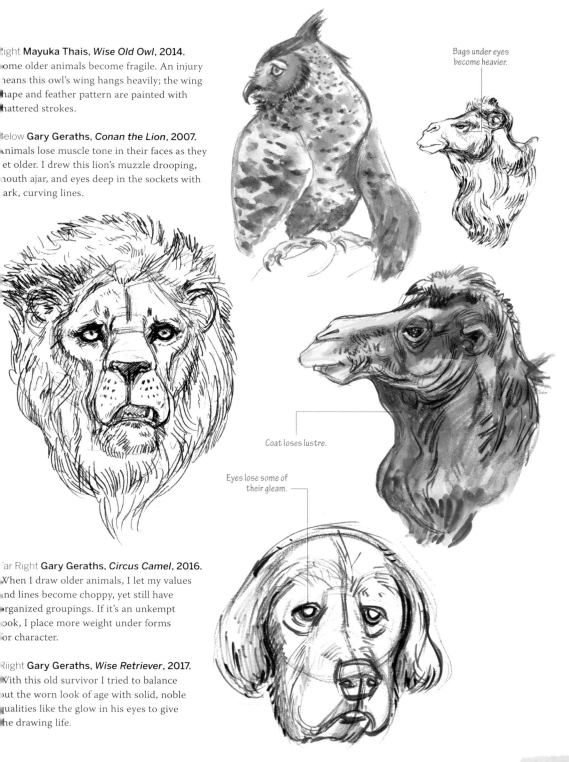

Right Mayuka Thais, *Wise Old Owl*, 2014. Some older animals become fragile. An injury means this owl's wing hangs heavily; the wing shape and feather pattern are painted with shattered strokes.

Below Gary Geraths, *Conan the Lion*, 2007. Animals lose muscle tone in their faces as they get older. I drew this lion's muzzle drooping, mouth ajar, and eyes deep in the sockets with dark, curving lines.

Bags under eyes become heavier.

Coat loses lustre.

Eyes lose some of their gleam.

Far Right Gary Geraths, *Circus Camel*, 2016. When I draw older animals, I let my values and lines become choppy, yet still have organized groupings. If it's an unkempt look, I place more weight under forms for character.

Right Gary Geraths, *Wise Retriever*, 2017. With this old survivor I tried to balance out the worn look of age with solid, noble qualities like the glow in his eyes to give the drawing life.

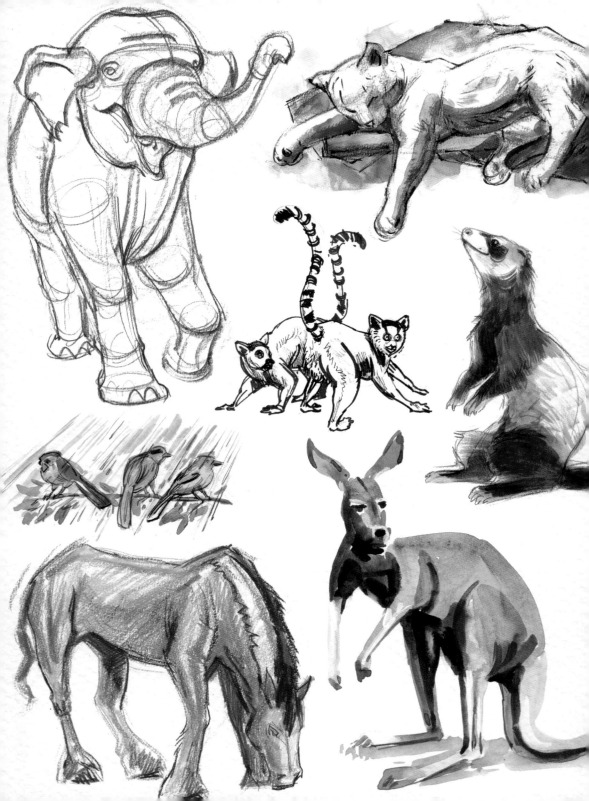

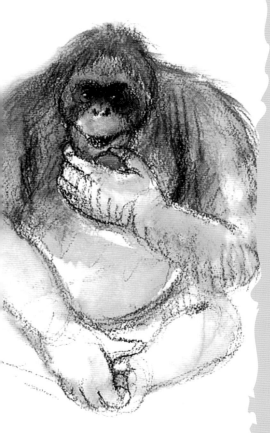

Materials and techniques

Up to this point we have been understanding and constructing action-packed and volumetric animal drawings. Now we will deal with the wide variety of expressive media and how you can use them to fill your sketches with texture, light, movement and meaning. It's exciting learning how to handle the different wet and dry drawing and painting materials that are at your disposal, but this is not a "one size fits all" approach. You will be doing a good deal of experimenting with these materials, especially when it comes to mixed media. Ask opinions of other artists, try out materials on found surfaces and different papers — do the unexpected. Enjoy exploring the process, whether creating a quiet composition of your pet at home, or a wild field sketch of rhinos and lions on an African safari.

Left Expressing your personal vision is a big part of drawing animals. Knowing how to use a wide variety of media will assist you in that goal, as well as give you more pleasure and produce better drawings.

Quick graphite sketching

Drawing with a pencil is the most accessible and easy method to practice, but gives you a huge variety of results. It is a very forgiving material that can be used in expressive and/or illustrative ways. The key is in using that versatile pencil in a decisive fashion to produce a powerful image.

Tips to get you started

1 **Power pencils** Since the pencil is so easy to work with and can be used for so many jobs, it comes in a huge variety of shapes, sizes and hardness. For quick sketches, try using a big, thick pencil. It can give you a wide range of marks and tones, and is an ungainly and clumsy material that won't allow you to concentrate on unnecessary details, making you focus on big, gestural strokes and speeding up your process.

2 **Letting loose** When quickly sketching animals, readjust your hold on the pencil. Most beginners draw as if they are writing a letter or holding a fork vertically. Instead, lay the pencil in the palm of your hand horizontally with the sharpened end pointing out from between the index finger and thumb. Then draw with a combined motion of the wrist and arm so you get big sweeps of pencil. It may feel strange at first, but with practice it will allow you to capture a wider variety of action and form.

3 **Close at hand** With any new material or technique, it's best to practice on subjects that are readily available. Family pets are the best; they are used to you being around (remember — they really own the house) and frequently just lay around, and so are perfect subjects.

Let loose with your pencil and sweep around the page with fast, inquisitive strokes, searching out form and texture. Chances are you will be comfortable working by yourself and more willing to experiment and then compare and contrast the drawings you come up with. The more mistakes, the better: you've got a lot in you. Best to get them out as soon as possible.

4 **Many marks, many textures** Vary your strokes over the drawing. Make them overlap for thick fur. Swing the wide side of the long pencil lead over the page to indicate long, shaded forms or soft, rounded masses of hair or skin. Lay down curving lines contrasted with short, squiggly lines. Take some chances and see the results.

5 **Wet pencils** Though not readily available in stores, aqua pencils are a nice extra piece of gear. Their lead is soluble in water, which means you can handle it in many ways. The best way to get a flat, tonal wash with a bit of texture is to lay down a big, quick field of marks and then wash water over it with a brush pen filled with clear water. Then, while the page is still wet, layer some more thin pencil marks over the drawing and the marks will swim around and create a unique image of soft and hard edges.

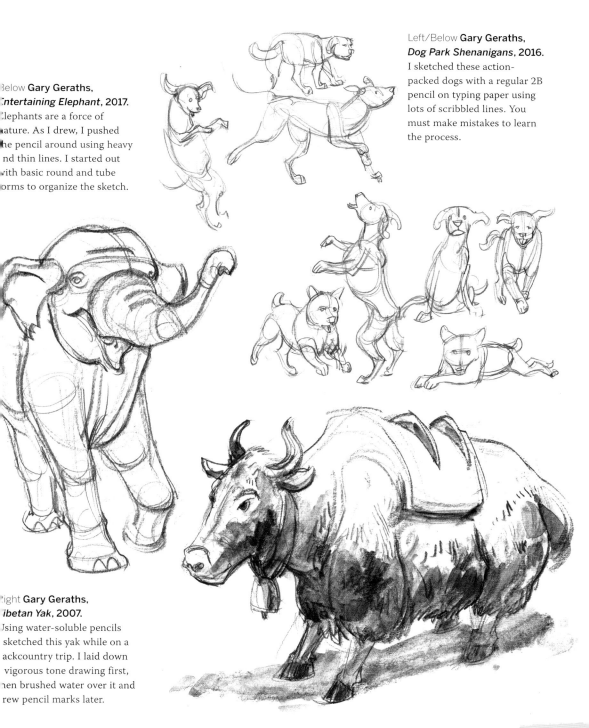

Left/Below **Gary Geraths,**
Dog Park Shenanigans, 2016.
I sketched these action-
packed dogs with a regular 2B
pencil on typing paper using
lots of scribbled lines. You
must make mistakes to learn
the process.

Below **Gary Geraths,**
Entertaining Elephant, 2017.
Elephants are a force of
nature. As I drew, I pushed
the pencil around using heavy
and thin lines. I started out
with basic round and tube
forms to organize the sketch.

Right **Gary Geraths,**
Tibetan Yak, 2007.
Using water-soluble pencils
I sketched this yak while on a
backcountry trip. I laid down
a vigorous tone drawing first,
then brushed water over it and
drew pencil marks later.

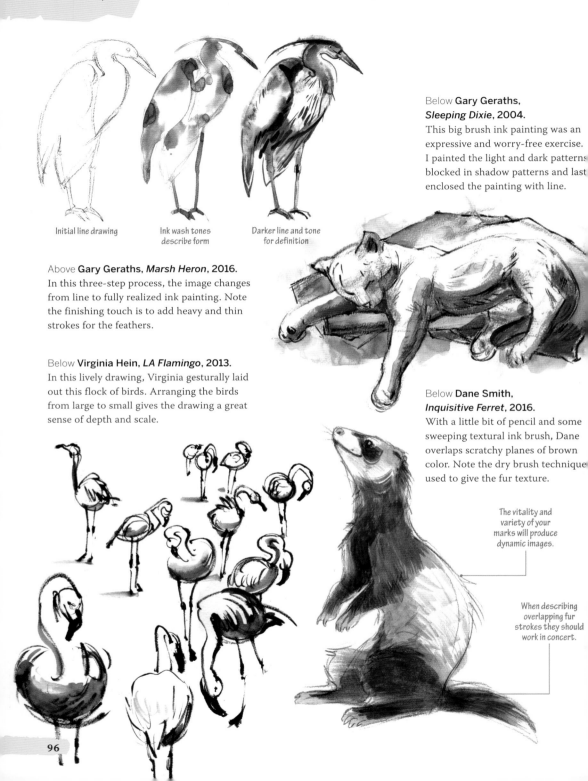

Initial line drawing

Ink wash tones
describe form

Darker line and tone
for definition

Below **Gary Geraths,**
Sleeping Dixie, **2004.**
This big brush ink painting was an
expressive and worry-free exercise.
I painted the light and dark patterns
blocked in shadow patterns and last
enclosed the painting with line.

Above **Gary Geraths,** *Marsh Heron*, **2016.**
In this three-step process, the image changes
from line to fully realized ink painting. Note
the finishing touch is to add heavy and thin
strokes for the feathers.

Below **Virginia Hein,** *LA Flamingo*, **2013.**
In this lively drawing, Virginia gesturally laid
out this flock of birds. Arranging the birds
from large to small gives the drawing a great
sense of depth and scale.

Below **Dane Smith,**
Inquisitive Ferret, **2016.**
With a little bit of pencil and some
sweeping textural ink brush, Dane
overlaps scratchy planes of brown
color. Note the dry brush technique
used to give the fur texture.

The vitality and
variety of your
marks will produce
dynamic images.

When describing
overlapping fur
strokes they should
work in concert.

Ink brush-painting

Though it takes effort to assemble and learn to use a portable kit for ink painting in the field, the technique of using ink washes and brushes brings huge dividends in the creation of quick, decisive images. Study past masters of ink animal painting for inspiration and techniques.

Tips to get you started

1 **Ink and brushes** To paint out in the field with ink takes organization and practice, but the finished results are worth the effort. If you look around, there are several types of ink — solid blocks, liquid, even tubes. Also, brushes don't have to be expensive or specialized. Find what works best; preferably they will hold a lot of ink and come to a sharp point. You will also need a non-breakable bottle to keep your water in, and a towel to wipe off the excess ink. Planning ahead will save you a lot of frustration and mess when you are drawing in the field.

2 **Fluid approach** Given you are working with water-based media, there will be unintended results in your work. The ink can be used in many ways. Acquire a lot of light-toned ink in a brush and paint in the shape of the animal, then add lines to cut in contours or texture details. For a simpler method, use just an organic brush line to quickly anchor in the outside contour line and a couple of facial features.

3 **Brush training** Ultimately, what will make this method successful is learning how to use the brush tip and washes of ink. There is a calligraphy of marks that comes from twisting and turning the brush, laying in wide paint washes or delicate, thin lines. There will be a shorthand suggestion of form and edges and an essence of movement in the fluid application. Practice independently of the subject; see what happens. Then, when you are in the field, you can confidently apply your newfound methods.

4 **Rhythm of marks** As you move your brush, the vitality and variety of your marks will produce dynamic images. To not waste effort, the strokes should work in concert, whether you are describing overlapping fur strokes or big blobs of volume and weight. Keep the visual rhythm of your techniques moving in a fluid motion. Start painting with a full brush and lay down the spine with a thin line that enlarges into the bulk of the head or torso.

5 **Mixed media** Using different wet and dry media together is a great way to communicate a vast array of animals. One technique is to lay down a base of pastel and then paint over the gritty material. This will give you a shadow pattern with a different, thick texture mixed in. Or perhaps you can do an under drawing using waxy china marker and paint over that. The marker will repel the water and create a rough surface illusion.

Speedy marker layout

For laying down value and color in a quick and controllable way, markers are definitely the way to go. Lightweight and easy to organize and draw with, they are a very user-friendly material when working out in the field, although they will take some practice and experimentation.

Tips to get you started

1 **Marker options** There are great many options when using markers. Since it is an "artificial" medium, marker tips can range from micro-thin to wide, chisel-ended brushes. Start out with a relatively small range of values from 10 percent grays to thick black. Some markers have two drawing tips — a small detail point at one end, and a wide chisel at the other — which can be flipped back and forth for a range of tones and marks.

2 **Marker painting** The makeup of the marker fluid comes in several solutions, and each handles in a different way. Some are water-based; the edges are softer and can be manipulated easier with slower drying times. Others are alcohol-based, with very quick drying times, allowing you to layer and create overlapping values.

3 **Marker tips and points** Marker tips are manufactured with a solid side and shape, so really explore their possibilities. In general, the very broad tips are used for blocking in big value shapes with wide sweeps of the hand. Medium tips can add texture planes and reinforce the movement of the animal. Use micro tips for facial features and quick details.

Learn how all these solutions work together; they can give you great results but also be very unforgiving.

4 **Bold Sharpie work** The simplest marker tools to purchase and use are Sharpies or permanent, medium-tipped markers. There's not much subtlety or finesse in these tools but you can find them everywhere and they are great drawing workhorses. The tips are rounded and lay down very black, solid lines for contour and accenting marks. As the markers start to dry out, don't throw them away. They can be turned on their side to give you a scratchy mark — a nice texture for thick hide or furry covering.

5 **Color markers** There are thousands of markers with their own individual hues of colors — it's easy to get swamped by all the choices. Select just a few to start out with and focus on a handful of options. Focusing on mainly earth colors will allow you to "paint" the hide and hair of a range of creatures. A rainbow of bright colors will allow for a wider range of artistic expression and visual impact. Or go for a mixture of both, capturing the realistic color of the animal and the warm lights and cool shadows that fall on the forms.

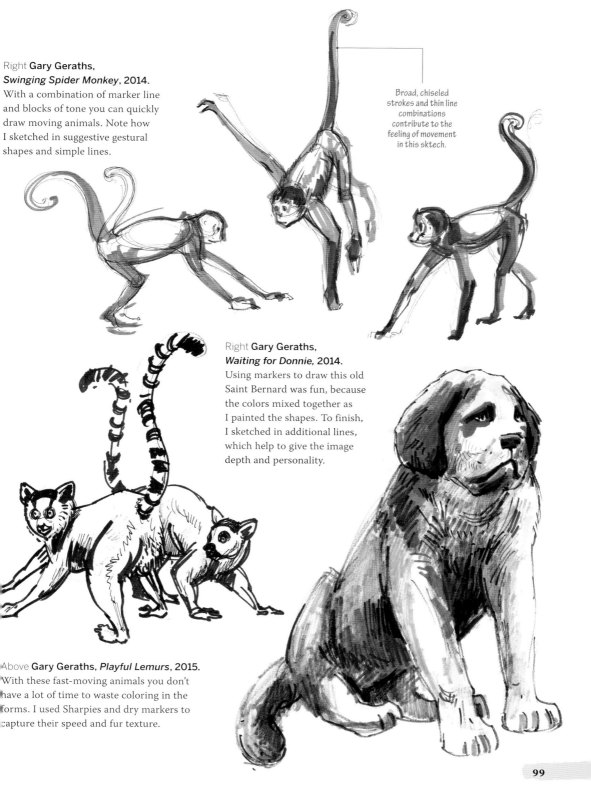

Right **Gary Geraths,**
Swinging Spider Monkey, 2014.
With a combination of marker line
and blocks of tone you can quickly
draw moving animals. Note how
I sketched in suggestive gestural
shapes and simple lines.

Broad, chiseled
strokes and thin line
combinations
contribute to the
feeling of movement
in this sktech.

Right **Gary Geraths,**
Waiting for Donnie, 2014.
Using markers to draw this old
Saint Bernard was fun, because
the colors mixed together as
I painted the shapes. To finish,
I sketched in additional lines,
which help to give the image
depth and personality.

Above **Gary Geraths,** *Playful Lemurs,* 2015.
With these fast-moving animals you don't
have a lot of time to waste coloring in the
forms. I used Sharpies and dry markers to
capture their speed and fur texture.

Below **Gary Geraths**, *Resting Tiger*, 2017. In this two-step painting I blocked in wet pools of warm and cool colors. After this layer dried, I used dry brush for the stripes and added more blue shadow colors.

Warm and cool watercolor pools

Dry brush for dark stripes

Below **Gary Geraths**, *Cool Kangaroo*, 2015. When I painted this big alpha kangaroo I wanted a very solid image, so I laid the paint on thick and kept the edges high contrast and concrete.

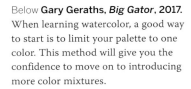

Below **Gary Geraths**, *Big Gator*, 2017. When learning watercolor, a good way to start is to limit your palette to one color. This method will give you the confidence to move on to introducing more color mixtures.

If you need to define an edge, use watercolor pencils to nail that quality down.

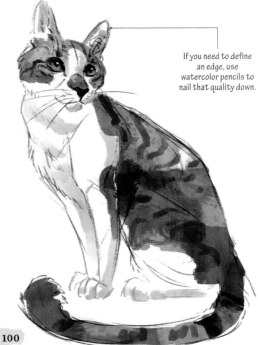

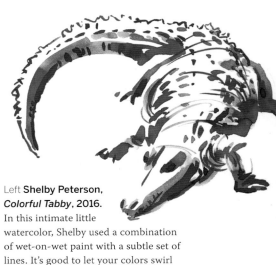

Left **Shelby Peterson**, *Colorful Tabby*, 2016. In this intimate little watercolor, Shelby used a combination of wet-on-wet paint with a subtle set of lines. It's good to let your colors swirl together for surprising results.

Watercolor painting

One of the most expressive and versatile mediums is watercolor. With a few colors and a couple of brushes, you can lay down a huge number of bold, descriptive marks in a short amount of time. Watercolor can make for a wonderful finished image or an underpainting for line work to be added later.

Tips to get you started

1 **Watercolors** Watercolor is built for going out and field sketching in color. There are thousands of colors you can buy but, frankly, I find it best to start with some primary colors — yellow, red and blue with some white gouache and maybe a little black (that I rarely use). A huge variety of hues, warm and cool colors, can be mixed from a limited palette, so experiment with your own methods before you have the animals in front of you.

2 **Watercolor kit** It's best not to burden yourself with lots of gear. Many varied watercolor kits are available, some with preselected colors, others to which you can add your own palette. Select one with a built-in, small, handheld mixing tray. As for the brushes, you don't need many, but it's good to know what the ones you use can do. One option is to use a wider brush with a good tip. You can mix up and load a lot of color to paint groups of subjects or larger images. If you buy a good brush that keeps an excellent point, you won't need a "detail" brush.

3 **Wet on wet** As you paint your animals, you are frequently trying to tell several stories about texture and lighting. Using the wet-on-wet painting technique can give you great results.

Lightly pencil in the shape of the animal you will be sketching. Next, mix up a big pool of warm or cool color and wash it into your sketch. Then, choose a different color and block it into the main wash. Don't cover the first wash; watch it mingle and flow with the others to create new mixes that may represent shadows or textures.

4 **Dry into wet** As the wet pools of color start to dry, you can take advantage of the haphazard nature of the painting. All those wet pools can have lost and found edges throughout the big forms. Now, mix new colors of thick impasto paint, and brush that dry paint onto the semi-wet first pass of watercolor. This will create a new set of color textures that contrast with the soft, washy initial painting.

5 **Pencil on watercolor** Often you will need to reinforce an edge or value corner. Use regular or watercolor pencils to nail those qualities down. Take a sharpened pencil, turn it on its side, and accent the areas you want noticed or textured, or choose another warm or cool watercolor color pencil and aggressively scratch into the wet or dry paint. This method can really bring a sketch together and is a fast problem-solving device.

Loose color-pencil drawing

Colored pencils are just the right instrument for quick animal drawing in the field, especially when creating scores of images. Sometimes all you need is a shirt pocket of pencils and a sketchbook to get you through a day of making art.

Tips to get you started

1 **Pencil for every use** One of the best reasons to choose colored pencils is that, given their waxy makeup, they don't smear much. Regular pencils have their advantages — they can certainly lay down an expressive mark and create a convincing picture — but graphite easily smears and you can lose all the marks you make, creating a mess on the paper and ultimately ruining the image. If you choose colored pencils, the drawings will look fresh and clear no matter what you put them through.

2 **Endless choices** There are a good number of companies manufacturing colored pencils of all sorts of hardness and color. One technique is to find a pencil with a softer "lead," sharpen it longer, and then use the big side of the point to paint the animal's form. Block in the shadow shapes and smaller forms to create a solid image. Then, use a harder pencil to punch up the textures and details.

3 **Pure value** A really great way to loosen up and get a very solid, quick drawing is to simply use blocks of value to hammer an animal's image onto the page. You can use a color-pencil block or the side of a china marker to knock out big planes and shapes that define the size and weight of the animal in action. It can be tricky, because it calls for an aggressive approach, but it will also ensure the shape and gesture don't get out of control. You can juggle these approaches, but make sure the correct image is the primary concern.

4 **Simple contours** In the opposite direction, you can reduce your drawing to just a few quick, continuous lines that define the outside border of the animal's form. Let your line copy, as close as possible, the proportions and line of action that surrounds your subject. Use a combination of long and short strokes to make bold statements strong enough to capture an impression of the animal.

5 **Multicolored pencils** There are literally thousands of colors in pencil form. Layering some of these colors into a series of drawings can add excitement, power or even an element of whimsy to your creations. Don't be afraid to lay down broad fields of one color and then aggressively scribble over complementary colors to build a solid composition. As before, it may mean making lots of mistakes, but you will see your progress as you move along.

Color-pencil sketch outline

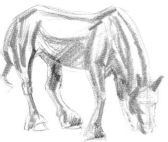

Swift shadow shapes

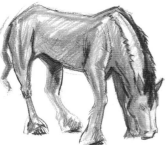

Darker detail and form

Above **Gary Geraths,**
Grazing Draft Horse, 2017.
When you are drawing large
animals, use big planes of color
pencil to get the image quickly
in place. Then lay in the shadow
shapes and dark anatomical forms.

Right **Gary Geraths,**
Proud Ostrich, 2015.
I furiously sketched in all of the
gestural big forms and the neck
and legs first. Then I colored in the
shadow pattern with cross-hatching
for volume.

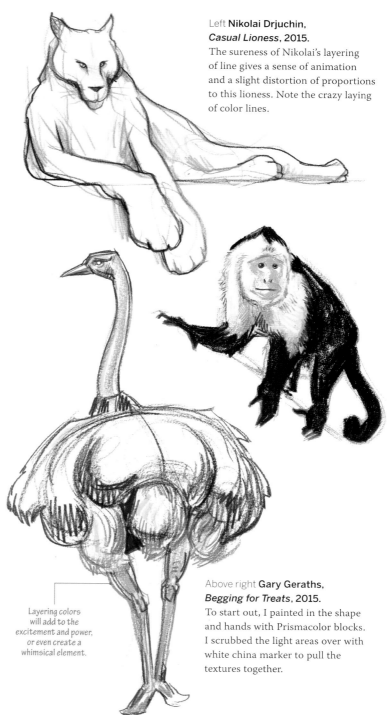

Left **Nikolai Drjuchin,**
Casual Lioness, 2015.
The sureness of Nikolai's layering
of line gives a sense of animation
and a slight distortion of proportions
to this lioness. Note the crazy laying
of color lines.

Layering colors
will add to the
excitement and power,
or even create a
whimsical element.

Above right **Gary Geraths,**
Begging for Treats, 2015.
To start out, I painted in the shape
and hands with Prismacolor blocks.
I scrubbed the light areas over with
white china marker to pull the
textures together.

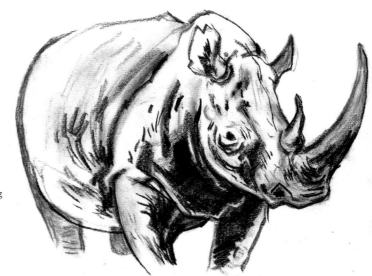

Right **Angie Geraths,**
Armored Rhino, **2016.**
Using a thick charcoal pencil
Angie, deployed high contrasting
light and dark values to give the
image a concrete feel. The value
contrasts also show off the
massive foreshortened volumes.

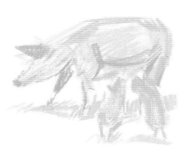

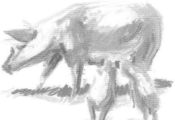

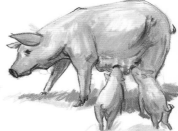

Animals sketched as one

Shadow shapes in pastel

Blue contour line added

Above **Gary Geraths,**
Busy Mom, **2016.**
To create this this sketch, I combined
all three pigs into one group with big
sweeps of pink and orange pastel. To
pull the image together, I used blue
contour line.

Left **Angie Geraths,** *Sly Fox*, **2016.**
Pastels get really messy, but you can
use that to make expressive images.
Don't be afraid to paint with the
pastels and then add outside form
lines to make the image solid.

Laying down pastel and charcoal

Being gritty and solid, pastels and charcoal have the ability to cover a lot of territory on your drawing in a very short time. With a couple of quick swipes of tone or color, you can almost block out an entire solid sketch. It may be a bit messy, but the results are unlike those of any other sketching material.

Tips to get you started

1 **Big and beautiful** When using both pastel and charcoal in the field, there's the potential to make a real mess of your drawings. On the other hand, there are many positive results that can be had from using these media. Pastel on rough paper with a good tooth gives a beautiful, full-bodied covering that can delineate an entire animal's body in one sweeping stroke.

2 **Layering tones and colors** Layering is a great technique to add solidity to your sketch — various colors sketched over one another create textures of different densities. Also, when you layer multiple colors, they visually mix and become unique colors to the eye. If the drawing is in danger of becoming too vague, add bold pastel or charcoal lines to anchor it.

3 **Erasing and fixing** Since the materials you are using are so powdery, there's lots of room for quick changes with a variety of erasers. There are almost as many kinds of erasers as pencils — super-soft kneaded erasers, block-shaped, all the way down in size to tiny pencil erasers. This myriad of erasers can give a universe of marks with some inventive thinking. Extra tones can be erased to mimic light on the animal's body. A bunch of single strokes can be erased to show hair or facial features.

4 **Pastel and charcoal pencils** If you like the materials, but perhaps not the mess, try using pastel and charcoal pencils instead. Because they handle differently they can give you a heavier value range, a textured surface and line control. Just a few colors will be enough when working in concert with the sticks of pastel or charcoal. Sharpen them into a point and sweep the colors over the paper's surface, then carve in the contour lines with different colors and line characters. Use a spray fixative to prevent smearing.

5 **Painting with charcoal** An interesting technique is to use water to paint with pastels and charcoal. Block in big shapes with either material, put down a layer and then use a brush filled with water to wash over the top, creating a thick, tempera-like "paint." As the surface dries, you can add materials to build up the texture.

Solid light and value

One of the objectives of using the materials discussed in this chapter is to achieve a solid image on the page, describing how lights and darks define the visual impact of the animal. You will need a combination of vigorous and delicate techniques to do the job, but with observation, practice and some thought, you will develop a great shorthand in drawing animals.

Tips to get you started

1 **Simple value blocks** If you are going to accomplish a solid representational sketch, it's best to really nail down the viewing angle, shapes and proportions of your subject animal. A perfect design isn't necessary to get started, but a fairly accurate one should be blocked in all the same. The next step is to block out the light and dark shapes to see how the light is falling over the animal's form. Keeping it simple is key to organizing your shadow patterns.

2 **Unique shapes** When attempting to quickly sketch a believable animal drawing, using the shadow pattern on the animal is a primary method to learn. Look at your subject and squint your eyes; that will automatically reduce the amount of details in both the light and dark forms. In essence, the shadow and light shapes inside the outer body contour will become high contrast white and black shapes. If you keep it simple and keep it clear, you will have a fun time making value sketches.

3 **Break down edges** One approach is to first use mid-tone values to block in the shapes of the shadows. Add darker shapes and curving edges to "carve" the animal out of the mid-tones. The last step is to use detail and highlight to bring the drawing to completion.

4 **Texture accents** The viewer's eye will look for visual information to tell a story about the animal you are drawing. After you have blocked out all the basic forms and proportions to identify what the animal is, it's time to show what the animal is made of. That means that as you build up the sketch, make note of fur patterns, facial features, age and anatomical points and then, when it's time, draw them into your composition. These accents aren't separate from the whole drawing but instead complement your creation.

5 **Background contrast** A nice little technique to complete a sketch is to, instead of adding a heavy outside contour line around the animal, use value contrasts behind the animal. Not only will this define the animal's outline, but also hint at the background environment. The contrast will make your drawing pop and jump off the page in a dynamic way.

Below **Gary Geraths**, *Sierra Mule*, 2015.
Having this willing model allowed me to take the time to combine loose wash painting and colored pencil. I made sure the features didn't drift away from one another while I painted.

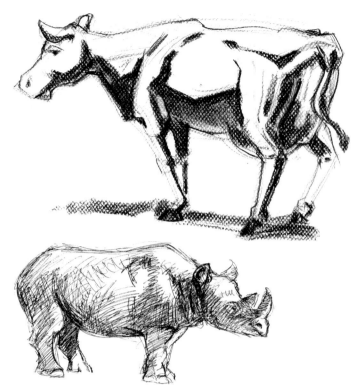

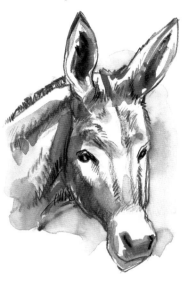

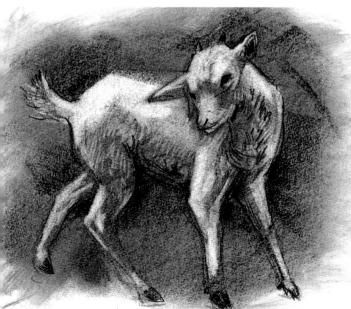

Top right **Gary Geraths**, *Lily Grazing*, 2015.
On a hot summer day I sketched this cow in charcoal with high contrast. The sharp light burns out the details in the upper parts of the body.

Above **Glen Eisner**, *Black Rhino*, 2013.
Using a rapid sketchy ink line, Glen built up a spontaneous shadow and light pattern. Note how the scribbled cross-hatching has different layers of darkness and texture.

Left **Gary Geraths**, *Playful Goat*, 2016.
I first scrubbed in a layer of flat charcoal on rough paper. Next I took a heavy eraser and carved out the light pattern, then added minimum contour lines.

107

Right **Gary Geraths,**
Grazing Gerenuk, 2015.
I wove crosshatched lines together
with long contour lines to make
an engaging image. Knowing an
animal's anatomy can increase the
sophistication of your shaded forms.

Below **Gary Geraths,**
Father Giraffe, 2013.
To get the interlocking lines right,
you have to change gears quickly
between a straight- and curved-
line character. Weave the lines
over the forms to tie it together.

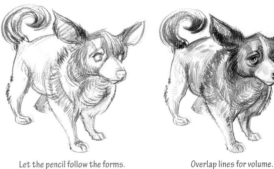

Let the pencil follow the forms. Overlap lines for volume.

Above **Gary Geraths,** *Papillon Jack*, 2017.
As I sketched our dog I had to really move
the pencils around its form. The solid fur
patterns helped guide the lines around the
body, overlapping the different forms.

Right **Gary Geraths,**
Arianna at Lunch, 2008.
With a handful of markers and
aggressive lines, I used a combination
of rounded and angular forms to tell
the visual story of this liger.

Volumetric cross-hatching

Cross-hatching is a dynamic technique that will give a concrete appearance to an animal's volumes in a drawing. It's a method that focuses on intertwining, overlapping lines, building interlocking forms that can make for very sculptural drawings, giving your sketches believability.

Tips to get you started

Weaving lines This is an interesting method to deploy in that you are weaving lines around the body of the animal. These lines go vertically, horizontally and diagonally over the volumes and intersect where the limbs, neck and head attach to the torso. That's not to say that's the only place where the lines overlap, but there is a rhythm of lines that move your eye over and around the drawing.

2 **Digging in** Let your eyes and lines explore the volumes of the animal you are drawing. Remember — if the form curves, your line curves. The same goes for flat planes with various straight lines and volumes. It's best to keep the hand moving; as the personality of the animal's body forms emerge, push a little harder on the pencil to add weight or show a sharp corner. It's important to watch how the lines communicate with each other in order to build a strong drawing.

3 **Curved lines versus straight lines** As you put all these lines together, you are creating a little story about how you see your subject. You can create long, thin horizontal lines for sleek, quick animals such as cheetahs and ferrets, while curving lines will work on rounded creatures like seals and puffy-haired dogs. When dynamically deployed, thin, straight lines will interlock and flow together with thick, curved strokes.

4 **Broken lines** Up to now, we have been looking at continuous lines moving together, suggesting the solidity of forms. Now it's time to break up the surface and add texture and surface anatomy. Lines will be heaviest in the shadow and lightest in the sun, but where the forms twist and turn, you can let your lines do the same. Lines might go over the form in the light, disappear and then reemerge and break into a pattern over the body's covering or shadow. Capture the movement over the textures and your image will achieve a lifelike quality.

5 **Smooth and sharp** It's at this point that all these shading techniques mass together. Often you won't have much time to get down a lot of individual marks, so, to get the process started, use base strokes of big gradient values across the drawing. This will unify the image and give it some presence. Then, lay in those crosshatched strokes to supply a more solid covering to your sketch. This back-and-forth drawing will give you a great interplay of gesture and mass.

Speed sketching — loose lines

Five minutes might seem barely enough time to sketch an animal's image, but in fact it's possible to capture a likeness even quicker than that. Try some extreme speed sketching to get the eye and hand to move faster. With this new urgency, your drawings will become looser and a more expressionistic.

Tips to get you started

1 **Expressionist marks** When you really get moving with that pencil or brush, chances are you will not be creating clean, representational artwork. These sketches will be messy and out of proportion, but they will be honest and full of energy. You are sketching visual notations and implied motion, not details. Move your hand quickly over, around and through the animal's body to describe the moving forms.

2 **Abstract animals** When you put yourself on an imaginary timer, there's not much hope that your drawings will resemble a photo — and nor should they. There should be a great deal of shorthand abstraction and suggestion to your drawings. Perhaps you will only get a small portion of the sketch successfully done with athletic lines. No matter. You will see the connections between those sketches and produce explosive and daring drawings.

3 **Action lines** Many of your speedy drawings will revolve around moving creatures. You can't ask a bird to pose during a takeoff, or a jumping dog to stop mid-leap so you can carefully sketch its

anatomy. You will be pushing and pulling the marks, furiously swinging and jabbing the pencil to describe the animal's action, and that actually may be the desired result. When you sketch, you are remembering and transferring the animal's movement and volume to lines.

4 **Casual viewer** Even an extremely loose drawing is still recognizable to the casual viewer's eye. Though it may be gestural, and even out of proportion, chances are your drawing of a horse won't look like an elephant or bird because of the animal's shape. Merely explaining the action with the basic shape of the animal will suggest lots of information.

5 **Quick color** Color can unlock all manner of levels in action lines. Just a few colors used by themselves or layered into a solid image can make for simple but believable sketches. One color can be used for implied movement, another for changing form, or perhaps for simplified anatomy. These sketches can be scribbled for enjoyment, for practice or as a shorthanded method of identification.

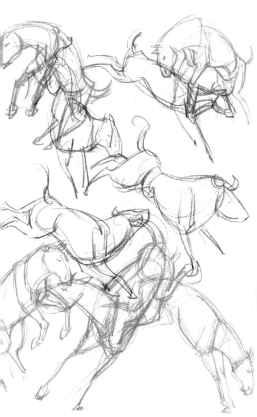

Below **Gary Geraths,** *Dayglo Rhino*, **2017.**
Using markers with fine and broad tips I laid
down exploring marks of value and lines. These
sketches are of various angles of the same
creature as it moved around.

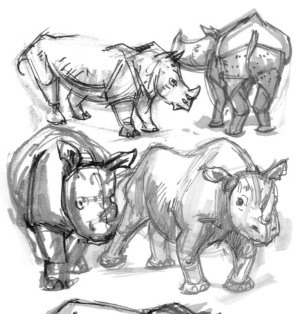

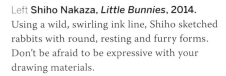

bove **Gary Geraths,** *Day at the Rodeo*, **2011.**
had a great time sketching the bucking
roncos and wild bulls in colored pencil.
 didn't matter if they weren't perfect —
was getting the action that was important.

Left **Shiho Nakaza,** *Little Bunnies*, **2014.**
Using a wild, swirling ink line, Shiho sketched
rabbits with round, resting and furry forms.
Don't be afraid to be expressive with your
drawing materials.

111

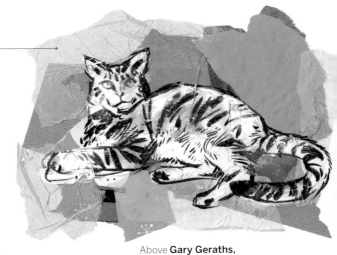

Wrapping paper glued
in random pattern to
use as ground

Below **Gary Geraths,**
Swirling Bunny, 2017.
Drawing this decorative rabbit meant I
didn't have to worry about the "realistic"
qualities. The outline came first, color
pencil next and then watercolor to finish.

Above **Gary Geraths,**
Christmas Kitty, 2016.
Just for fun, I glued down some used
Christmas wrapping paper in an erratic
pattern. I then painted my cat in big white
shapes with black ink for an exciting result.

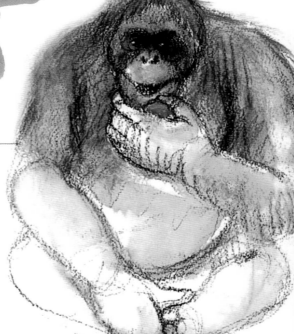

Swirls of color pencil
with watercolor wash

Watercolor wash
for color, scribbled
pencil for texture

Right **Virginia Hein,**
Orangutan at Lunch, 2006.
Using paint and pencil, color and
texture, Virginia drew an intimate
portrait. Mixed media sometimes
requires a fearless approach to
see what works and what doesn't.

Expressive mixed media

As you get to grips with the available sketching materials, you may become intrigued by how they can be combined and overlapped. There is a vast array of options to experiment and play with in your drawing habits. Practice is key. This topic will outline some of the possibilities.

Tips to get you started

First steps We have already looked at some fundamental mixed media, and even practiced a few techniques. Re-familiarizing yourself with these methods, such as mixing watercolor and line drawing, is important, because it will get your brain moving over familiar processes and reevaluating what animal drawing encompasses.

Preparation is key Practicing your techniques at home is one thing, but working in the field is another matter entirely. When sketching in situ, you will have to prepare ahead of time and pare down your drawing options. You could collage various decorative papers together to draw on when out and about. You could layer various wet paints into pools of color on various papers and let that dry at home, then take those papers and use more mixed media materials at the zoo. Use your imagination.

Fast layering With only five minutes to sketch while using mixed media, it's all about quickly switching back and forth between materials. Preparation and the ability to switch gears will lead to great results, but it's also a matter of how the materials work together. Try drawing the animal in wax crayon first. Leave lots of paper exposed, then apply expressive watercolor over that; the crayon will repel the paint. Then draw over that image with colored pencil or ink. Experiment with media.

4 **Papers and surfaces** A great way to start your mixed media experience is to use a collection of different papers with smooth and rough textures. Newspapers will give you a printed surface — a story to paint or draw on top of — and it's cheap as well! If you create a journal or diary, your words or observations could be included in your artwork. You don't have to restrict yourself to boring white paper; the surface you draw on is important.

5 **Personal expression** It's good to be able to paint and draw animals representationally, but personal expression is also a destination that must be explored to make a dynamic picture. That can take many paths, such as replacing the animal's surface textures with decorative patterns and bright colors, or perhaps drawing overlapping pictures of various creatures where the edges blur or disappear. The options are almost limitless. What is important is that you find your own voice in this process; ultimately, it will bring you the most creative satisfaction.

Animals in their environment

Placing animals in their home environment — the place they live — in your drawings is important. Not only will it enhance your overall compositions, but also give more of a sense of place, atmosphere and even narrative about how animals live, eat and survive.

Tips to get you started

1 **Pets at home** There's no better way of sketching animals where they live than in the comfort of your residence. If your pet settles on your lap or on the couch, you have a still, willing model surrounded by the comforts of home. Sketch the couch or rug your pet is laying on and make a great memento of the moment. Sit outside and draw the birds at feeding stations and in nests. It's always exciting to sketch a mother bird returning home to feed her growing chicks.

2 **At the zoo** Zoos build animal enclosures to represent the environment the creatures live in in the wild. These enclosures are simple and artificially built, but that doesn't mean you can't enhance the scene. Search the Internet to get a good idea of what the rocks look like or how the ground cover grows.

3 **Down on the farm** Sketching at a farm or stable is a relaxing way to spend the day. For the most part, the animals will be grazing quietly in the fields or corrals and interacting with other animals. As an added bonus, there is sometimes a backdrop of weathered buildings, with color and textures to add personality to your quick sketches. Make notes and fill in the details later.

4 **Aquariums and the sea** Aquariums and the seashore are great places to practice your craft Seals, otters and various sea birds can be sketched at public aquariums, but you can also find them in the wild. Whether it be puffins or polar bears, draw swimming animals using curving lines, liquid media and even bubbles to get the idea across. On the beach, you can sketch sea animals next to waves crashing on the beach, or draw them lounging on the rocks.

5 **Birds, ponds and lakes** Drawing birds is another relaxing experience in the wild, and just about any pond or small lake will give you the opportunity. Drawing a bird on the water's surface will require you to sketch in water ripples and reflections, with curving lines and patterns surrounding the floating bird. At marshes or reserves, there will be reeds or forests of cat tails to include in your sketch.

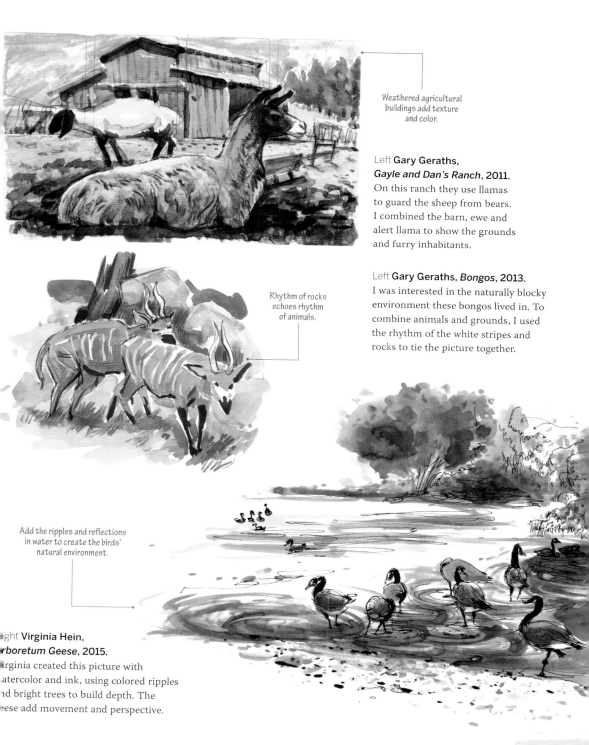

Weathered agricultural
buildings add texture
and color.

Left **Gary Geraths,**
Gayle and Dan's Ranch, 2011.
On this ranch they use llamas
to guard the sheep from bears.
I combined the barn, ewe and
alert llama to show the grounds
and furry inhabitants.

Left **Gary Geraths**, *Bongos*, 2013.
I was interested in the naturally blocky
environment these bongos lived in. To
combine animals and grounds, I used
the rhythm of the white stripes and
rocks to tie the picture together.

Rhythm of rocks
echoes rhythm
of animals.

Add the ripples and reflections
in water to create the birds'
natural environment.

ght **Virginia Hein,**
rboretum Geese, 2015.
irginia created this picture with
atercolor and ink, using colored ripples
d bright trees to build depth. The
ese add movement and perspective.

Above left **Gary Geraths,**
Kekko on the Couch, **2016.**
Compositions can be organic and not
conform to a typical rectangular frame.
I used the furniture and lamp to help
give a sense of a homey atmosphere.

Above right **Shiho Nakaza,**
Heron in Marsh Grass, **2014.**
The active grass texture and bird silhouette
bring the focus to the heron. A nice bonus
are the beautiful reflections of the pond.

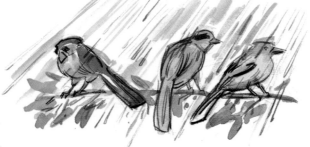

Above **Gary Geraths,**
Shelter in the Storm, **2017.**
Bringing the elements into a drawing
can make for an engaging composition.
The diagonal raindrops suggest action
and tie all the visual pieces together.

Right **Gary Geraths,** *Lioness Collage*, **2016.**
Frequently I will want to capture the entire
animal and draw the more interesting body
parts. By adding those pieces to a figure
composition, I can tell a personality story.

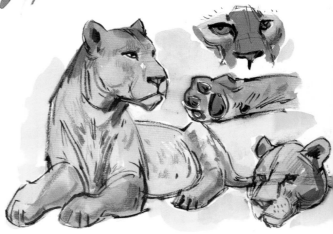

Creating dynamic compositions

Although this is the last topic, it almost feels like it should be the first. Using dynamic composition in animal drawing can mean many things. At its center is the idea of how one or many sketches design a page, or describe the animal and its environment. Consider the story you tell with an animal.

Tips to get you started

1 **Composing viewpoints** How you design and sketch animals will engage the viewer's attention. How you place information on the page will help tremendously. The first step is to put together all of the various elements you are witnessing and/or creating. These could include drawing an animal from high and low angles, light and shadow, and focal points. To start building dynamic compositions, make those elements part of your concept.

2 **Personal stories** You can create subtle compositions by including your pet, your home and even other family members in your drawings. That's a lot to get into a five-minute sketch, but in that time you can set up, block everything in and fill it in later. You can set the time of day, lighting, even the furniture.

3 **Portraits and pieces** Another composition you can construct is drawing various parts of the animal on one page to inform the viewer about the personality of the creature. Choose any animal and sketch its whole body on the page, but leave room for items that intrigue you. That

could be a couple views of the head or facial features. Then, draw feet, hands, claws or wings. You might even quickly sketch some action poses to add flavor to your composition.

4 **Atmosphere and place** You can use the light of day (or night) and shadow shapes to build a dynamic composition. An animal will be surrounded by some kind of environment (indoor or outdoor) and it can be welded into the composition. Look to use the primary light and reduce it to high contrast light and dark to sketch it in. Then add and subtract value, and you will have a "landscape" that has your animal as its focal point.

5 **Special effects** Most of the time, you will happily be drawing in sun or pleasant weather. But if storytelling is a focus of your composition, you could add a sense of drama and weather to your drawing. Maybe it's windy, or there is a ground fog or even rain. A quick sketch can be built up into a really innovative composition that contains mood, emotion and a sense of you being in the middle of the action.

Colored and textured grounds

There are ready-made paper pads available with a wide range of colors, giving you warm, cool or neutral gray fields of color to draw on top of. Warm materials generally go over cool grounds, cool over warm, and gray grounds will take any colors you choose.

Tips to get you started

1 **A simple start** One of the main reasons to use colored paper is that it gives you a simple yet rich background on which to put your animal figure. You can buy papers with rough or smooth textures of various colors, but a good, cheap way to get started is to use cut-up brown grocery bags. Use the paper as a mid-tone and build light and dark colors or tones out of that. Start with black, earth tones and white colored pencils; the pencil marks don't smear and the thick paper will take the aggressive drawing.

2 **Keep the paper color** Vary your techniques and try not to obliterate the paper color. Let it shine through as you lay down marks. Use soft, wide passages of pastel or ink and then build up individual strokes of thick and thin intensities of color on the surface. Use earth tones to block in the figure, then can lay in sharp, brighter colors that complement and create visual interest.

3 **Cool custom papers** There are so many creative surfaces and grounds you can buy and create to draw and paint on. Besides colored grounds you can find papers with

leaves and organic materials mixed in — great for watercolor and creating random edges and shapes. I like to use dyed papers that have unique patterns and give nice textural surfaces for animal drawings.

4 **Do it yourself** Consider making your own grounds and surfaces. A great technique is to take pieces of paper or illustration board and coat them with acrylic paint or gesso, or even mix in colored paint. This process allows you to control the degree of rough or smooth ground and the intensity of color. Draw over the paper's uneven surface with vigorous charcoal marks, watercolor washes, overlapping sweeps of pastel or a mixture of all of these materials.

5 **Extra time** Often you won't have time in the field to complete your sketch in a five-minute time limit; the ground may not allow enough drying time for your painting, or you may need to spray fix it to the surface. Stand back and examine how your drawing works with the ground you have sketched on. It may be that you will want to continue working on it.

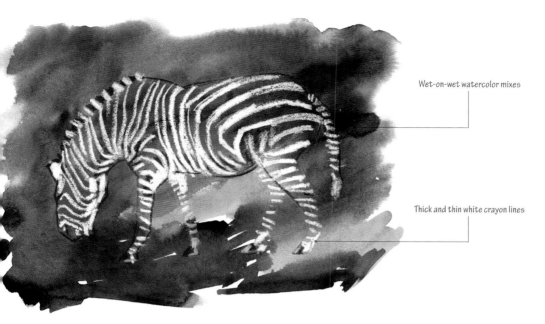

Wet-on-wet watercolor mixes

Thick and thin white crayon lines

Above Gary Geraths, *Crayon Zebra*, 2016.
Using wet-on-wet watercolor technique I painted an abstract background. With a white crayon I drew in the stripe pattern to suggest the animal's volume.

Above Gary Geraths, *Chameleon*, 2017.
This beautiful little reptile was drawn on a warm ground pastel paper. The saturated cool greens and blues become more vibrant and the image pops off the page.

Right Gary Geraths, *Playful Birddog*, 2017.
The very rough paper creates a great sense of layered colors and furry texture on this dog. Random effects will appear on surfaces like this, but don't be afraid to use the "mistakes."

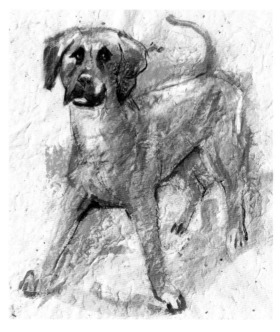

Steps for future successes

The aim of this book has been to give you enough information to learn to quickly sketch and paint a variety of animals. From here on out, it's up to you to progress, to motivate yourself, to improve and to be successful, but here are some additional suggestions to help you expand your drawing techniques, advance your creativity and explore new artistic techniques.

Tips to get you started

1 **Find like-minded people** One of the best ways of expanding your knowledge and gaining confidence is to put together a like-minded group of animal sketchers. This can happen as easily as bumping into fellow artists drawing at the zoo and joining them — in fact, I met half the artists that have contributed images to this book that way! Once you've found others with the animal-sketching bug, you can compile email groups or teams via social media, arrange trips and exchange drawing tips.

2 **Explore the web** The Internet is a wonderful resource. Watch videos online of animals in action and examine their body rhythms and dynamic movements. Research the base anatomy of basic animal types (cats, dogs, horses, cattle, birds) and do some quick sketching from these diagrams. Observe the methods and materials of other artists.

3 **Material journal** You may run into roadblocks as you explore the endless variety of materials in this artistic endeavor of animal sketching. To create your own solutions in your drawing,

keep a materials and techniques "diary" or journal. Make swatches of various combinations of painting and drawing materials, then add notes to help you keep track of your experiments and their results so you can confidently apply them in the field.

4 **Get off the couch** Sketching animals gives an artist a great excuse to get out of the house and travel about. The wider the variety of domestic and exotic animals you look at and sketch, the better you will get. Seek out new locations near you or, even better, make a vacation of it. Pack up your gear and go sketch your heart out. It'll give you a chance to get out in the fresh air, and your confidence will build as you sketch.

5 **Finance your artistic journey** One incentive for improving your craft is to help pay your bills! As your drawing progresses, it's not a stretch to imagine that, with a bit of effort and luck, you can start taking commissions and selling your artwork. Use social media to promote your unique talent and display your art, urging yourself onward to becoming a better artist.

Right **Gary Geraths**, *Roma Portrait*, 2015.
This is a little gouache commission painting
of a quarter horse, Roma, at a county fair.
Painted on site, I tried to capture the look
and personality of my "model."

Below **Gary Geraths**,
Artists at the Zoo, 2015.
A group of urban sketchers drawing a
curious hippo, drawn in watercolor and
pencil. We use these trips as an opportunity
to exchange drawing techniques and get a
morale boost.

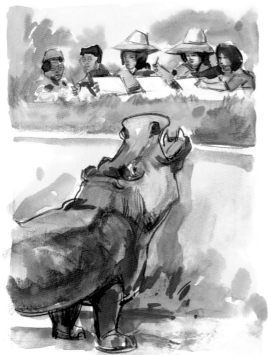

Below **Gary Geraths**, *Material Swatches*, 2014.
With so many art materials to choose from,
I use these swatches to help keep track of how
the effects of watercolors, pastels and markers
work together.

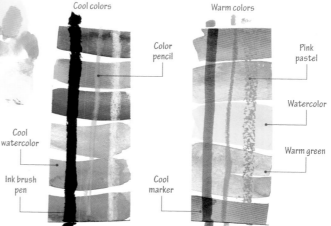

Cool colors

Warm colors

Color
pencil

Pink
pastel

Watercolor

Warm green

Cool
watercolor

Ink brush
pen

Cool
marker

Warm color mix

Watercolor mix;
pastel stripes

Key elements

Being able to draw recognizable heads, body shapes and features is vital for making your animal drawings believable, but with so many types of animal out there, it can get confusing! The good news is that with a few bendable rules and helpful tips, it should be relatively easy to master the structures, personalities and expressions of all manner of animals.

Head shapes and structures

Birds

You can't go wrong starting out with a simple oval shape to which you can add a beak to match your subject's face. The diamond-shaped beak fits right over the front and into the cheeks like a mask.

Dogs

No other animal has so many variations of basic head shape. That can vary from a circle/ball for a bulldog to an elongated oval/egg for a wolfhound. Use the simple but elastic rounded form as the basis for the skull, then add a box or triangular form for the muzzle.

Cats

With their large jaws and relatively small muzzles, cats — big and small — have a rounded or shortened oval shape to their heads. One big difference between cats and dogs is that cats have wide cheekbones which make for a firm, round form. Dogs have heads that taper at the sides.

Cows and horses

When drawing these heads, there are a couple of points to keep in mind. The head shapes are very square in cattle-like animals and rectangular in horse-like creatures. The addition of short or long, wide or narrow muzzles will complete the whole structure.

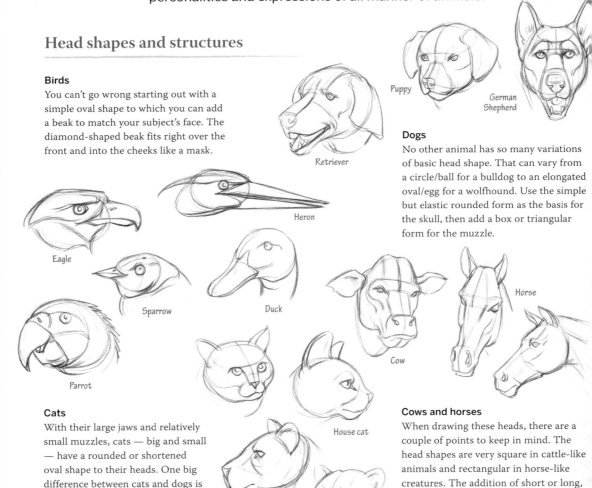

Puppy

German Shepherd

Retriever

Heron

Eagle

Sparrow

Duck

Cow

Horse

Parrot

House cat

Tiger

Lioness

Ears — shapes and connections

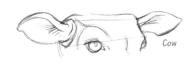

German Shepherd

Dogs

With all those varieties of dog ears, it's best to draw the ears' general shape to begin with. Ears can be very curvy, or have angular forms, but don't forget to create a curving arc at the top of the head to attach the ears to.

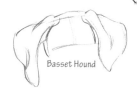

Basset Hound

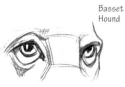

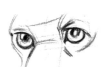

Cow

Cats

Felines need great hearing for hunting, so their ears are always snapped up to attention. Big cats tend to have rounder-shaped ears, while house cats' ear tips are pointy, but both have curving connections to their heads at the base.

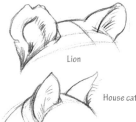

Lion

House cat

Cattle

Many cattle and similar animals have ears that are mounted horizontally on the sides of the head, below a set of horns. Use a spoon-like shape with a blunt-ended tip as a guide when you sketch them in.

Eyes and placement

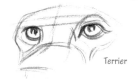

Basset Hound

German Shepherd

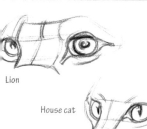

Lion

House cat

Dogs

Dogs' eyes can vary from small and very beady to large and soulful. The shape is generally an oval with an angle downward to the nose. I focus a lot on dogs' eyes because they seem to bring out so much emotion and personality.

Terrier

Cats

Cats are hunters, so their eyes are placed on the front of their heads. There are usually curving upper eyelids that wrap around the temple, with a lower tear duct that accents the sides of the nose.

Cows, giraffes and horses

Grazing animals are constantly looking out for predators, so their large eyes are placed on the sides of their heads. Pay attention to and accent the thick brow and eyelids that provide shade and protection for the eyes.

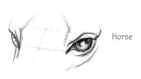

Horse

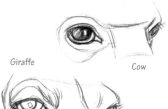

Giraffe

Cow

Sheep and goats

These animals' eyes are generally placed high on the face and are surrounded by fur and fleece. They are rounded, with big eyelashes and smallish brows which, when drawn right, can give the animal a unique character.

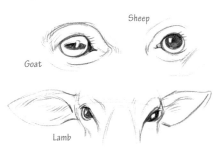

Sheep

Goat

Lamb

Hooves — shapes and forms

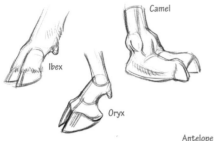

Camel

Ibex

Oryx

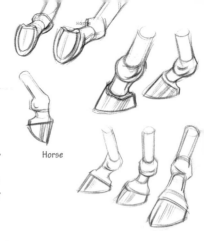

Horse

Horses' hooves
Cattle and horses share the same general construction, but what is different is the horse has one solid, plow-shaped wedge for the hoof. Remember the "horse-shoe" shape of the foot and create a thick, boxy edge to the back of the hoof.

Hoof structure
The best way to organize the great variety of animal hooves is to construct the foot as "pipes" and "balls" that are glued together but moveable. When it comes to sketching in the hooves/ toenails, break them down into parallel triangular wedges.

Antelope

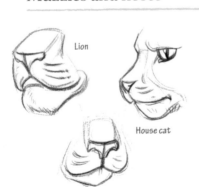

Elephant

Cow

Elephant hooves and feet
Elephant — and rhino and hippo — hooves are constructed out of cylindrical/tube forms that fit into large, domed feet complete with separate curved toenails. Hippos' and rhinos' toes emerge from the foot in individual triangular wedges.

Muzzles and noses

Lion

House cat

Horse

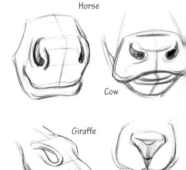

Cow

Giraffe

Lamb

Dogs, foxs and wolves
It's hard to pin down a specific shape that represents the nose of every dog breed, but in general they have a thick wedge or shield shape. The nostrils are formed like commas, indented into the nose and curving horizontally out to the muzzle.

Cats
Big cats have solid, blocky muzzles that contain very large teeth, compared to house cats' muzzles which are smaller in proportion to their head size. What they have in common, though, is that both have triangular-shaped pads at the tips of their noses.

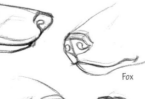

Wolf

Fox

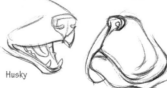

Husky

Boxer

Cows, giraffes, sheep and horses
Though all of these creatures have muzzles of differing shape, they share the qualities of thick lips and cheek pads for elastic chewing. Don't forget to correctly place those big, curving nostrils across those boxy, wide noses to add character.

Paw structure

Cat paws

With all that fur and those retractable claws, cats' paws take on a rounded but also rectangular form. If you look at the paw from underneath, it has a shell-like scallop shape with dark, oval pads arranged like a fan.

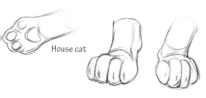

Lion

House cat

Dog paws and claws

When I sketch dog paws, I make sure that they are fairly thin and bony in appearance, with their claws showing constantly. I also give the back of the dog's foot a curving heel that pushes the toes out in front of the leg.

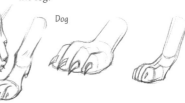

Dog

General proportion rules

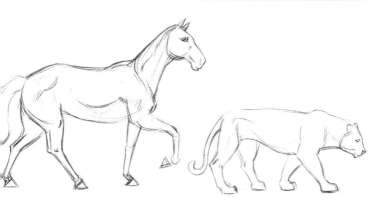

Variations in size

Because of the huge variety of proportions in animals, these rules should be considered very elastic in application. The best tip to use in dynamic sketching is to compare and contrast the proportional differences in the height and width of the animal. For example, the height and length measurements of horses and some dogs are equal. They also have fairly square proportions. On the other hand, cats and cattle have a rectangular set of proportions.

Foreshortening animal forms

Animals in depth

As animals move around, they assume poses and move in directions that are difficult to visually organize and sketch. Simplify them into shapes and volumes like balls, tubes and wedges, then sketch through the forms to see how the overlapping lines collide on top of and into one another. Look to where the torso collides with the legs, or how the head comes forward in perspective and the proportions change.

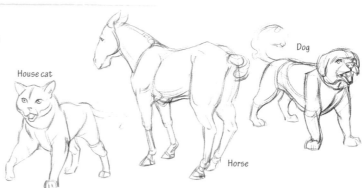

House cat

Dog

Horse

Index

Acknowledgments

Author Acknowledgments

This book was quite a labor and honor to write and to illustrate, and just wouldn't have happened without the help and support of many people. My wife Joyce kept me and the family sane and steady through the many hours of writing and drawing while trying to meet tight deadlines. A special thanks to all the artists who took the time to make and contribute these drawings and sketches. It was a blast going through all the submitted artworks and selecting all the images in this book. I humbly bow down to all of your talent and efforts.

Special thanks go to Nick Jones, who expertly edited my endless run-on sentences and bad metaphors to helped craft a very readable book. Also a heartfelt thank you to Abbie Sharman and her team at RotoVision, who took my scribbles and finger painting and managed to expertly design and compose the layouts, images and text. All that effort resulted in this informative book you see in front of you. I hope you enjoy the learning experience, and that it helps you in your practice and in becoming a better artist.

Artist websites

Jackelyn Bautista
getjackedbyjackie.tumblr.com

J.A.W. Cooper
www.jawcooper.com

Nicolai Drjuchin
www.nikolaidrjuchin.com

Glen Eisner
www.instagram.com/chavantsavant

Gary Geraths
www.garygerathsart.com
www.instagram.com/garygeraths

Virginia Heim
worksinprogress-location.blogspot.com

Julia Henderson
www.instagram.com/i_am_julia_h/

Tayen Kim
www.thestarkat.com
www.instagram.com/tayenkim/

Alexa Nakamura
dttey.artstation.com

Shiho Nakaza
www.shihonakaza.com
shihonakaza.blogspot.com

Holly Overin
www.instagram.com/hollyoart

Shelby Peterson
www.shelbypeterson.com

Kayla Ryyth
www.facebook.com/kaylaconcepts/

Abi Savage
www.Instagram.com/Avocadobakesale

Dane Smith
www.DanishDraws.com

Mayuka Thais
www.mayukathais.com
www.instagram.com/mayukathais

Yumi Yamazaki
www.yumiyamazaki.wixsite.com/yumi

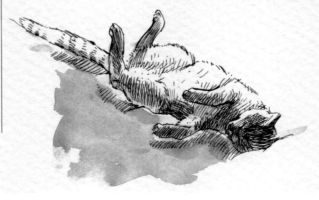